Northwest Lighthouses

A Coloring Collection

Volume 2

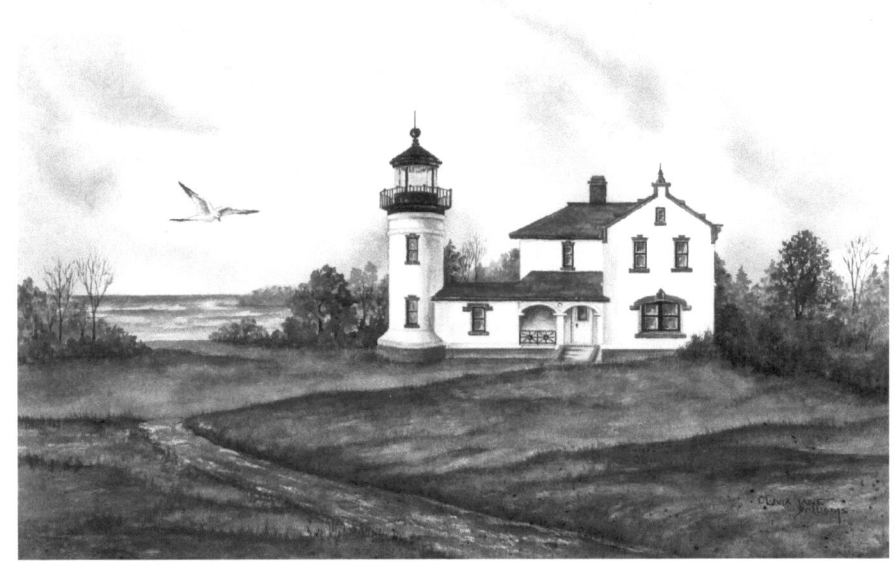

created by

Olivia Jane Williams

Copyright © 2017
Adult Coloring Book by Olivia Jane Williams
All rights reserved

No part of this book may be reproduced, transmitted, or stored in any form, or by any means, except for your own personal use or for a book review, without the express written permission of the author.

ojwilliams.39@gmail.com

oliviajanewilliams.com

ISBN-13:978-1548769376

10-1548769371

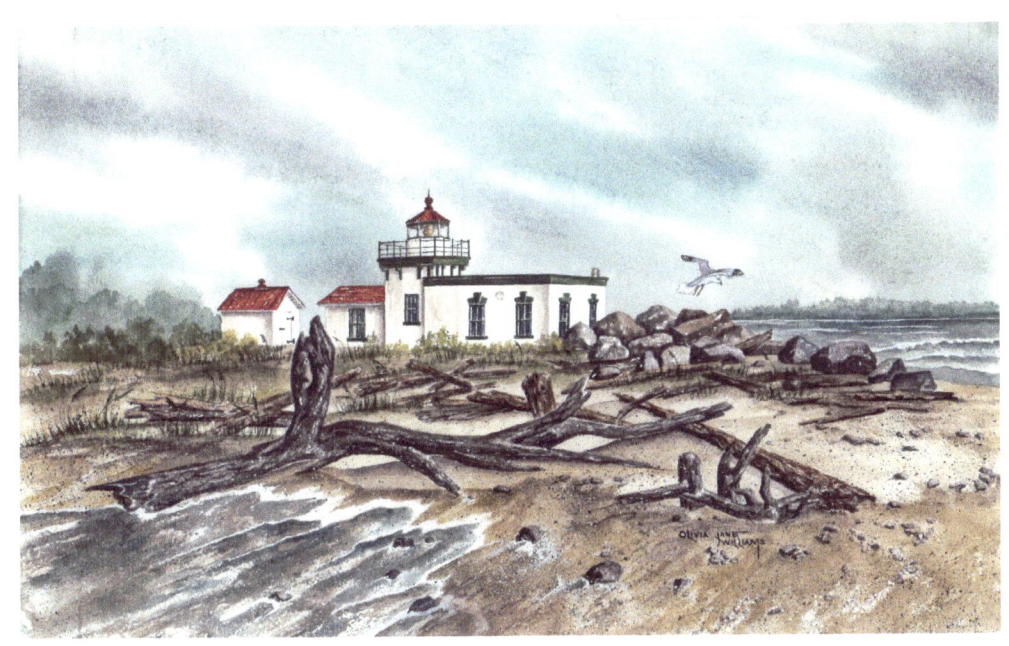

This book is dedicated to the United States Lighthouse Society, headquartered at Point No Point Lighthouse in Hansville, Washington, the Lighthouse Environmental Programs sponsored by Washington State University, at Admiralty Head Lighthouse, located on Whidbey Island, the U. S. Coast Guard, and all the groups and organizations that adopt, restore, and maintain the lighthouses of Washington and Oregon.

Many volunteers devote unlimited time and energy to the restoration and maintenance of the structures and grounds surrounding them, and provide information and guided tours to the many visitors who frequent them. Their efforts to perserve and share the critical role lighthouses performed in our maritime history is greatly appreciated.

CONTENTS Page

Thirteenth District Lighthouse Map 5
Lighthouse Keeper's Page 6
Washington Lighthouse Map 7

 Cape Disappointment 8-9
 New Dungeness 10-11
 Cape Flattery 12-13
 Admiralty Head 14-15
 Point No Point 16-17
 North Head 18-19
 Point Robinson 20-21
 Browns Point 22-23
 Alki Point 24-25
 Destruction Island 26-27
 Grays Harbor 28-29
 West Point 30-31
 Mukilteo 32-33
 Point Wilson 34-35
 Lime Kiln 36-37
 Gig Harbor 38-39

Oregon Lighthouse Map 41
 Tillamook Rock 42-43
 Cape Meares 44-45
 Yaquina Head 46-47
 Heceta Head 48-49
 Umpqua River 50-51
 Cape Arago 52-53
 Coquille River 54-55
 Cape Blanco 56-57

With the acqusition of the Oregon territory, and increased ocean commerce on the West Coast, the U.S. government saw the need for ships navigational aids. A U. S. Coast Survey Team was sent to explore places of greatest need of lighthouses, and made recommendations for several points along the coast. By 1852, congress authorized sixteen lighthouses and other navigational aids.

In 1881, a map was created of the Thirteenth Lighthouse District, to show lighthouses in operation. As trade and commerce increased, and the number of ships and crew were damaged or lost, other sites were added and lighthouses constructed.

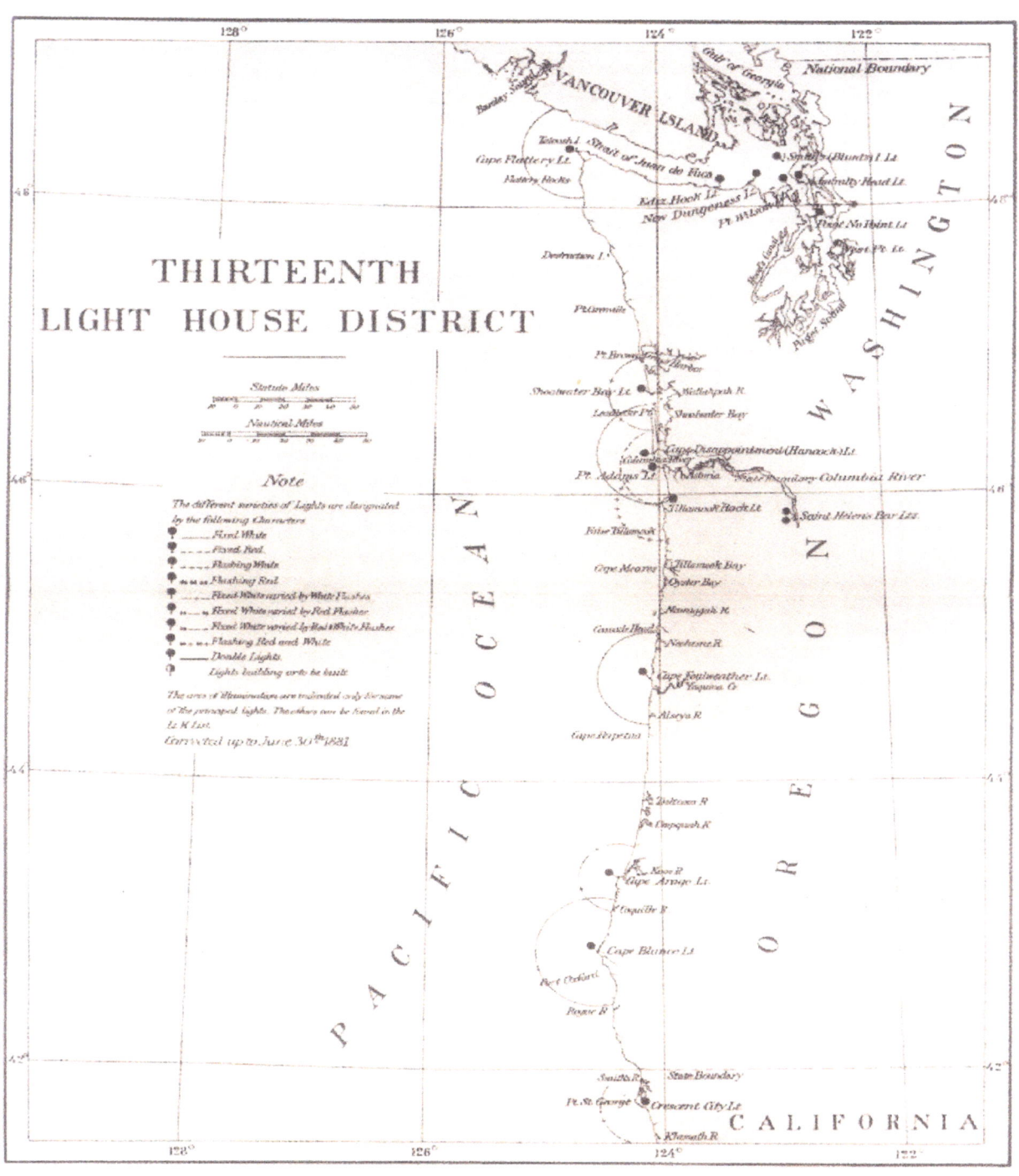

1881 Map of the Thirteenth Lighthouse District

The Keeper's Log, or journal, was a required record for the Lighthouse Service. Keepers were instructed to record the weather, supply deliveries, maintenance and repairs made, special events, visitors, who were invited to sign the log, and ships signaling arrivals or departures.

The Lighthouse Journal (example)

JOURNAL of Lighthouse Station at 1901 Cape Flattery		KEEPER William W. Windsor
Month	Day	RECORD OF WEATHER and EVENTS
Dec.	2	Cloudy wind 30 knots HMS 'Condor' signaled as it passed the island - SW course headed into turbulent sea and weather
Dec	3	No report of 'Condor' heavy rain
	4	Fog, rain, squalls Condor bound for Honolulu and S. Pacific - no reports (after 35 days and no report, the HMS 'Egenia' was order to search - no members of the 100 crew or vessel were found) The 'Umatilla' lightship was blown off course at the time the 'Condor' went missing.

Lighthouse keeper's uniforms, navy blue wool, were issued by the Lighthouse Service, and they were required to wear them when on duty. On the lapel jacket of the principal keeper was embroidered a gold "K".

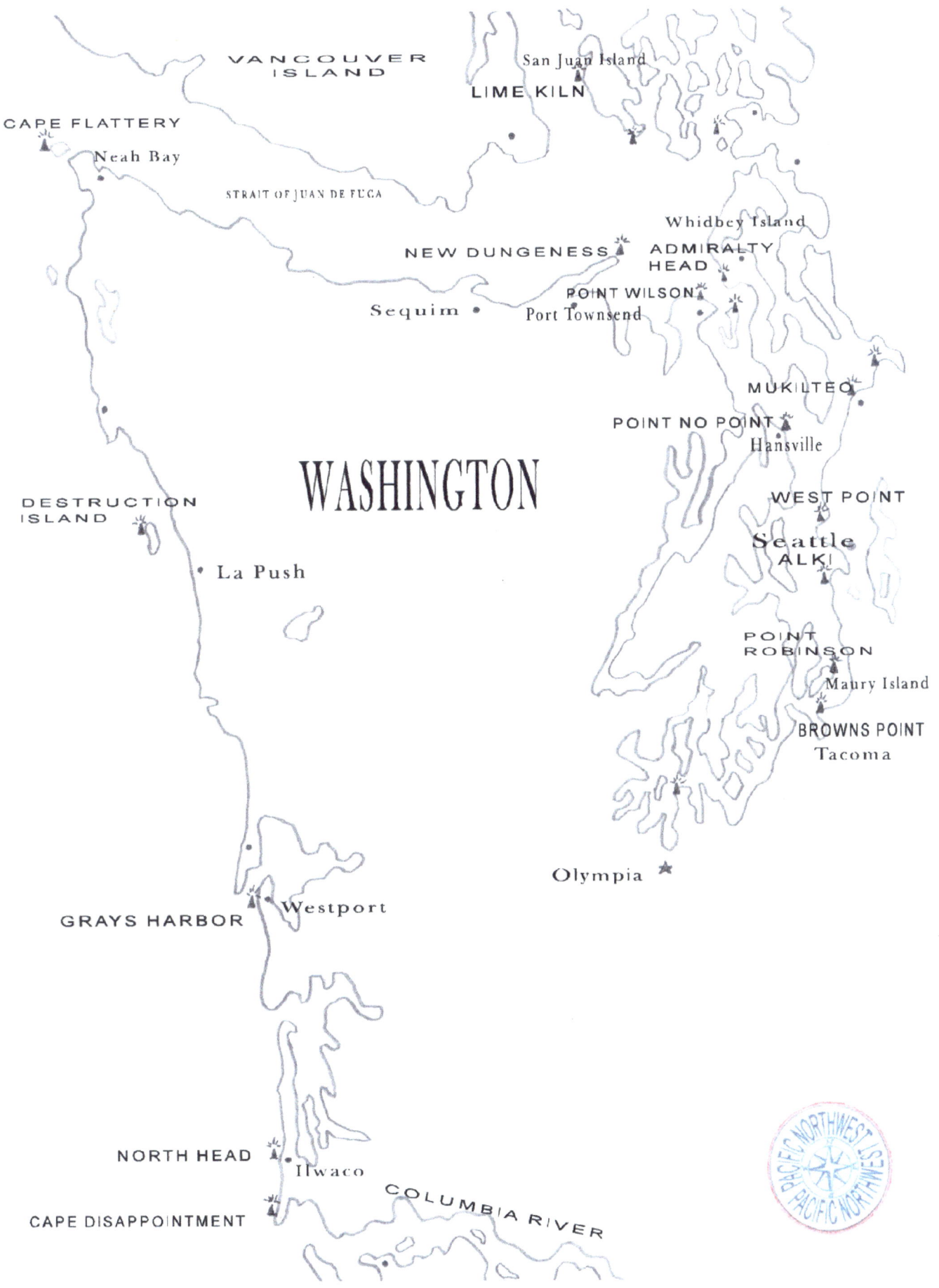

Cape Disappointment Lighthouse, the oldest in the state, stands on a bold headland overlooking the meeting place of the Columbia River and the Pacific Ocean near Ilwaco, Washington. It was given a first-order Fresnel lens and lit on October 15, 1836. When North Head Lighthouse was constructed, it's lens went to North Head and was replaced by a fourth-order lens.

The fifty-three foot black and white tower is a day marker as well as a lighthouse. Many vessels have met their destruction on or near this rocky cape. Because the waters are so turbulent, and the rocks so threatening, the U. S. Coast Guard uses it for a training location.

In 1864, Fort Canby sprang up around the lighthouse. The Fort's remains and The Lewis and Clark Interpretive Center are now famous visitor's attractions.

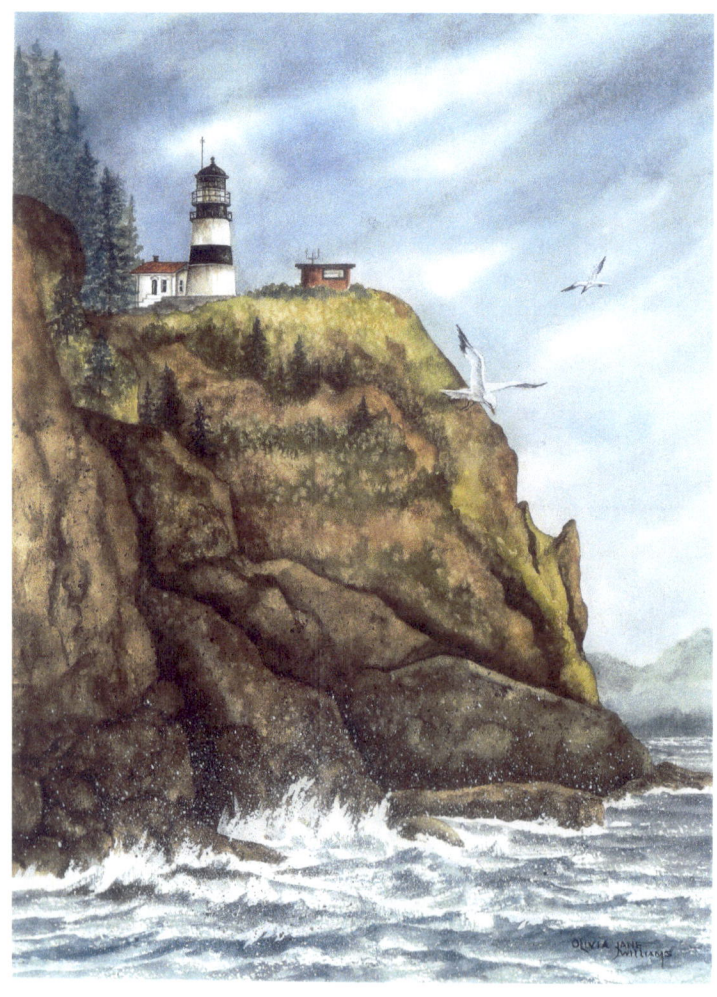

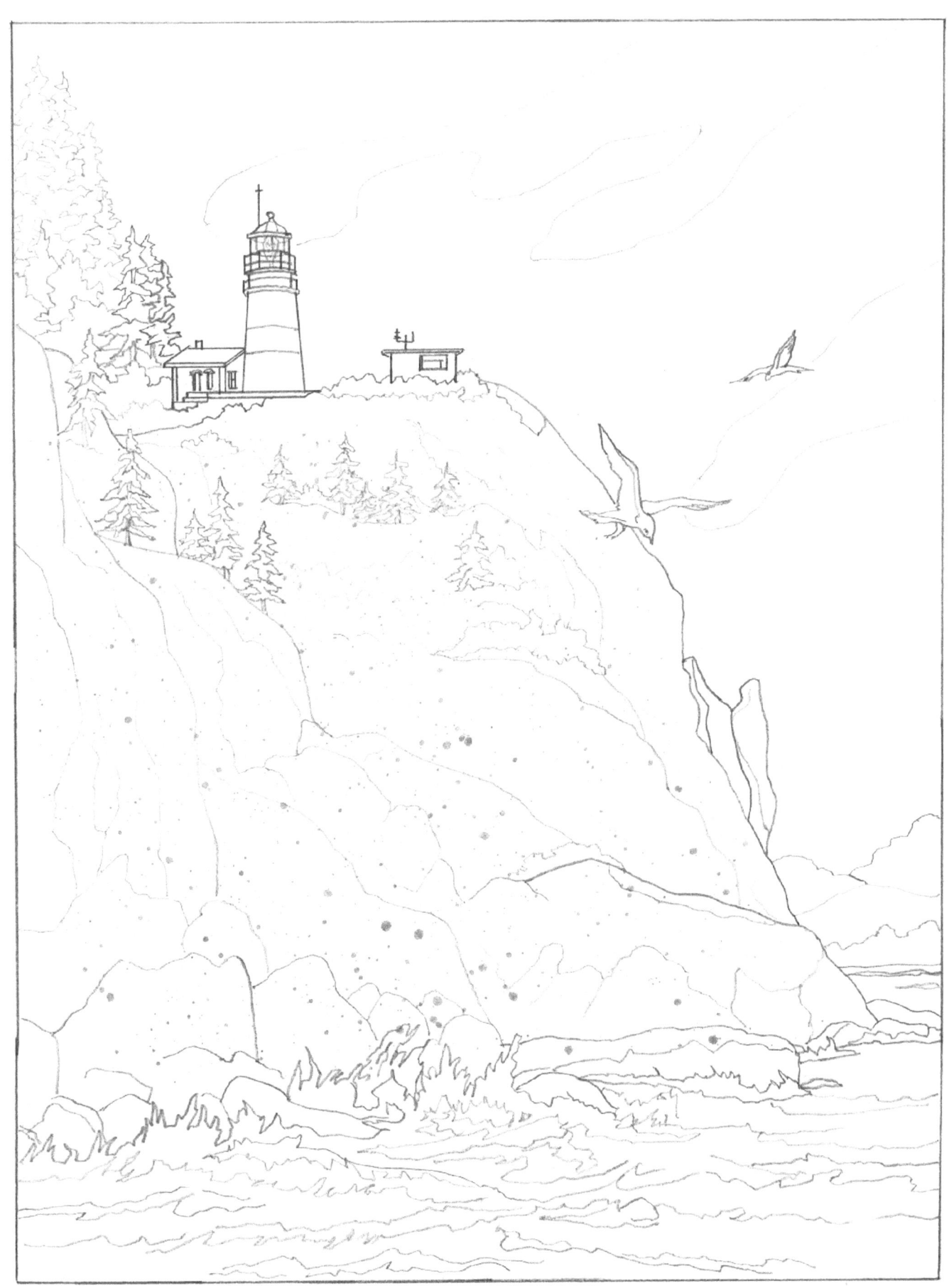

CAPE DISAPPOINTMENT - 9

New Dungeness Lighthouse, located at the end of an eight-mile spit from Sequim, jutting into the Straight of Juan de Fuca, was constructed in 1857. The eighty-nine foot tower was equipped with a third-order Fresnel lens. In 1927, due to the deterioration of the upper part of the structure, it was reduced to a height of sixty-three feet, and the old lantern was replaced by the abandoned tower at Admiralty Head. In the nineteenth century, the sandspit near the lighthouse was a battleground for invading Indian tribes.

With the increasing numbers of cargo vessels entering the strait, the station's light, fog signal and radio beacon are a critical aid to navigation.

The lighthouse, buildings and grounds are maintained by volunteers and guests who spend weeks serving as tour guides and 'lighthouse keepers.'

Fourth Order Lens

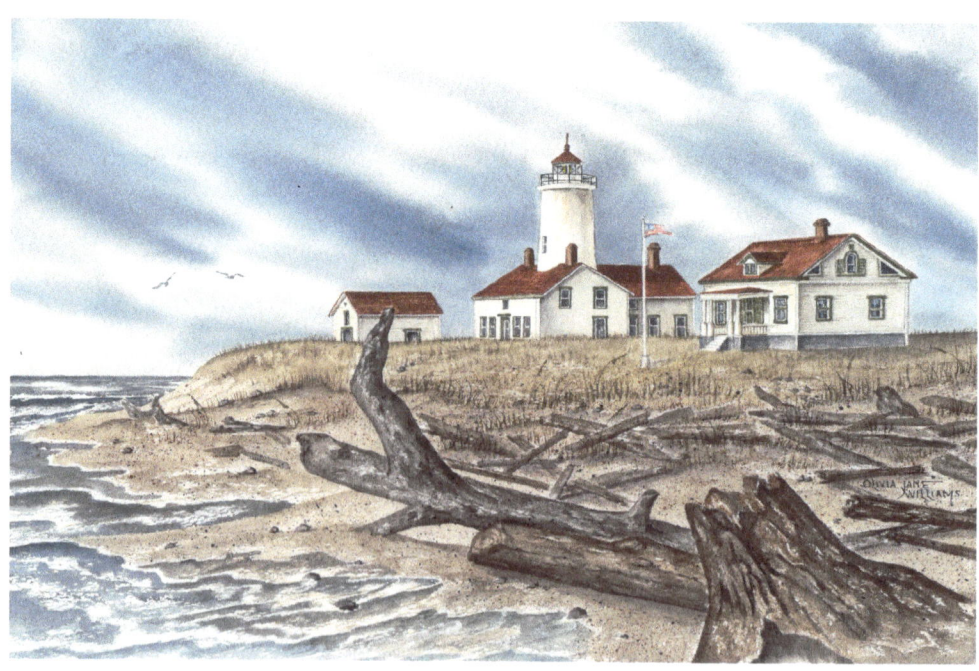

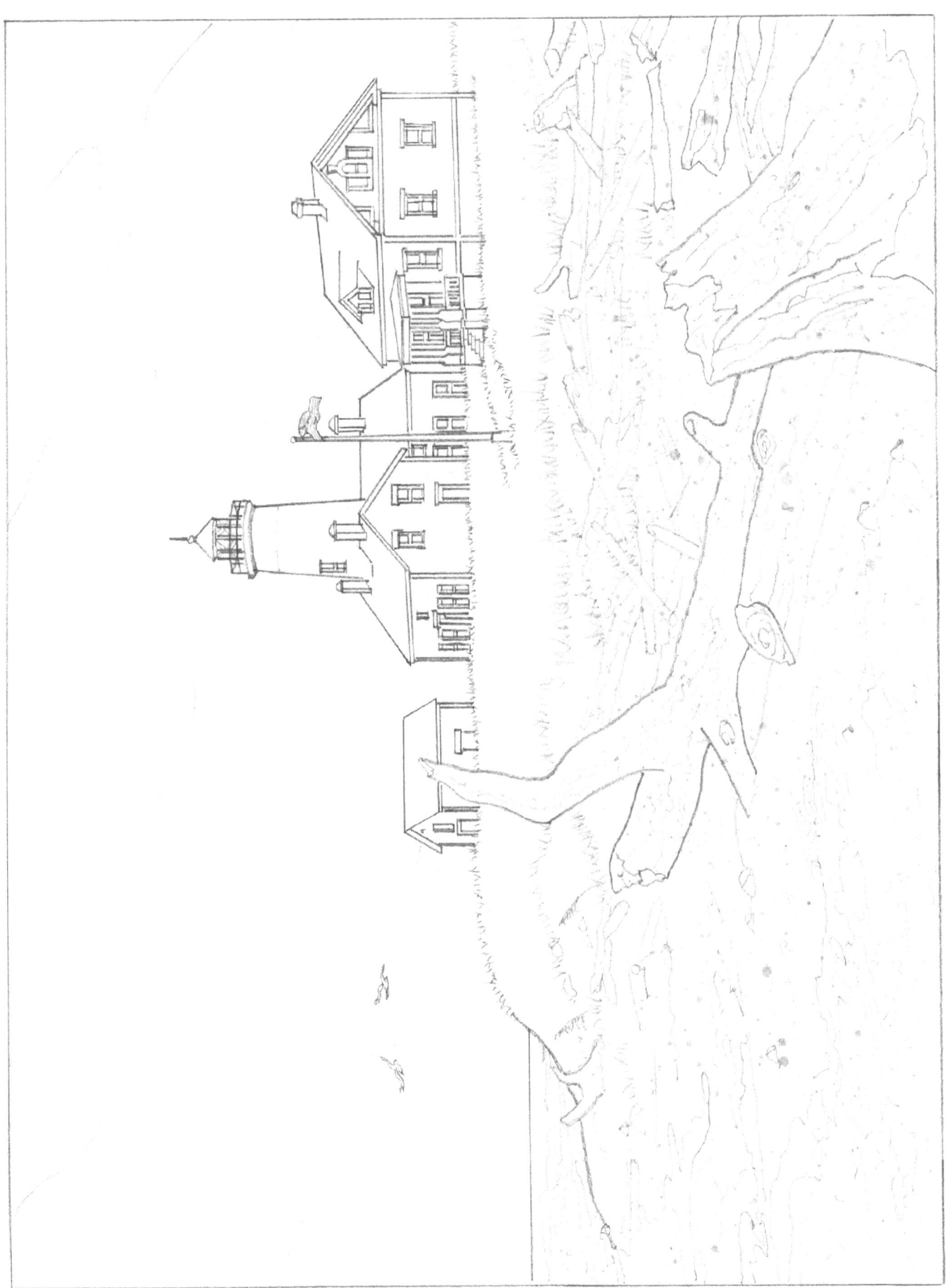

New Dungeness - 11

Cape Flattery Lightouse is situated on the furtherest western point of the Contentintal United States, on Tattoosh Island in Neah Bay, Washington, at the entrance of the Strait of Juan de Fuca.

The arrival of a construction crew, and the erection of a lighthouse, was a most unwelcomed intrusion to the Makah Indians, who lived there, and others who frequented the island to catch salmon and spear whales, and hold potlatches.

Congress alloted funds for the lighthouse's construction in 1854, but it was December 28, 1857 when the light first cast it's beacon out to sea.

There was a frequent turn-over in personnel until, in 1860, Capt. William W. Winsor of Port Angeles became principle keeper, and was both dedicated to his office and to peaceful relations with the Indians. In time, the Indians and the station's personnel co-existed in harmony, and as late as the turn of the century, the Indians held potlatch ceremonies there.

In 1883, a weather station was installed on the island. and became a major reporting station to the U.S. Weather Bureau.

The rocky shore around Cape Flattery hold the remains of countless numbers of vessels, their crew and cargo. Many ships leaving the Strait of Juan de Fuca were never seen or heard from again.

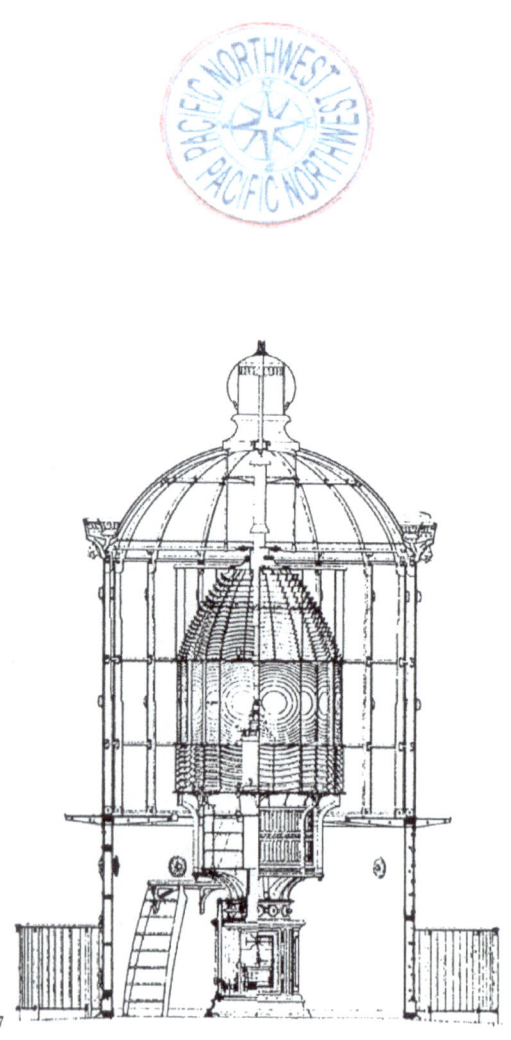
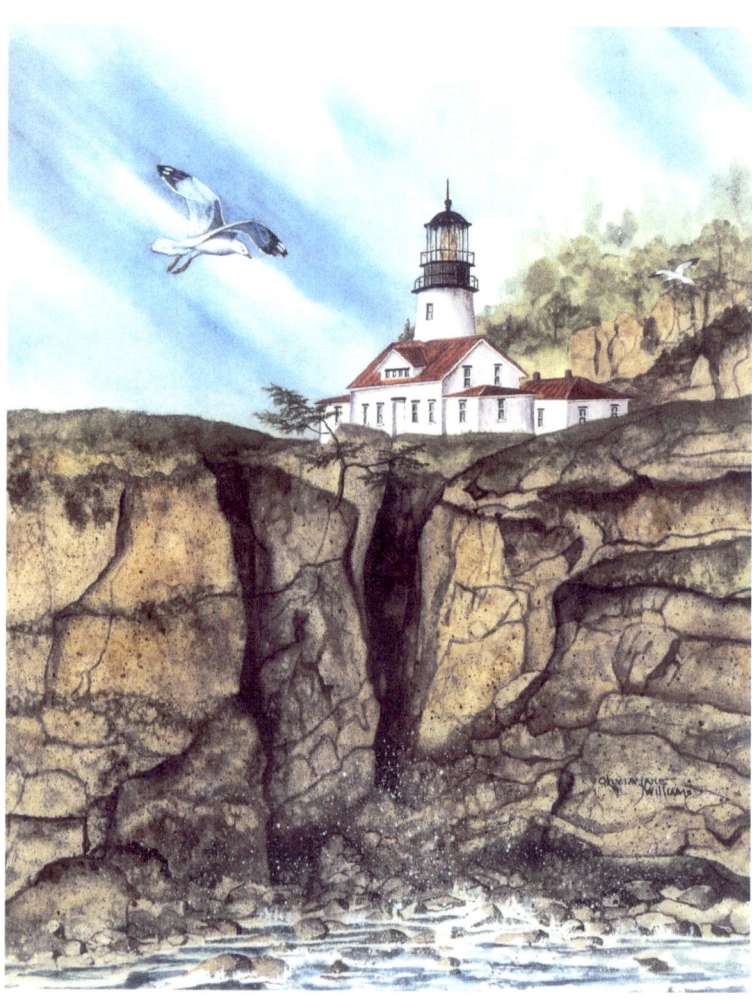

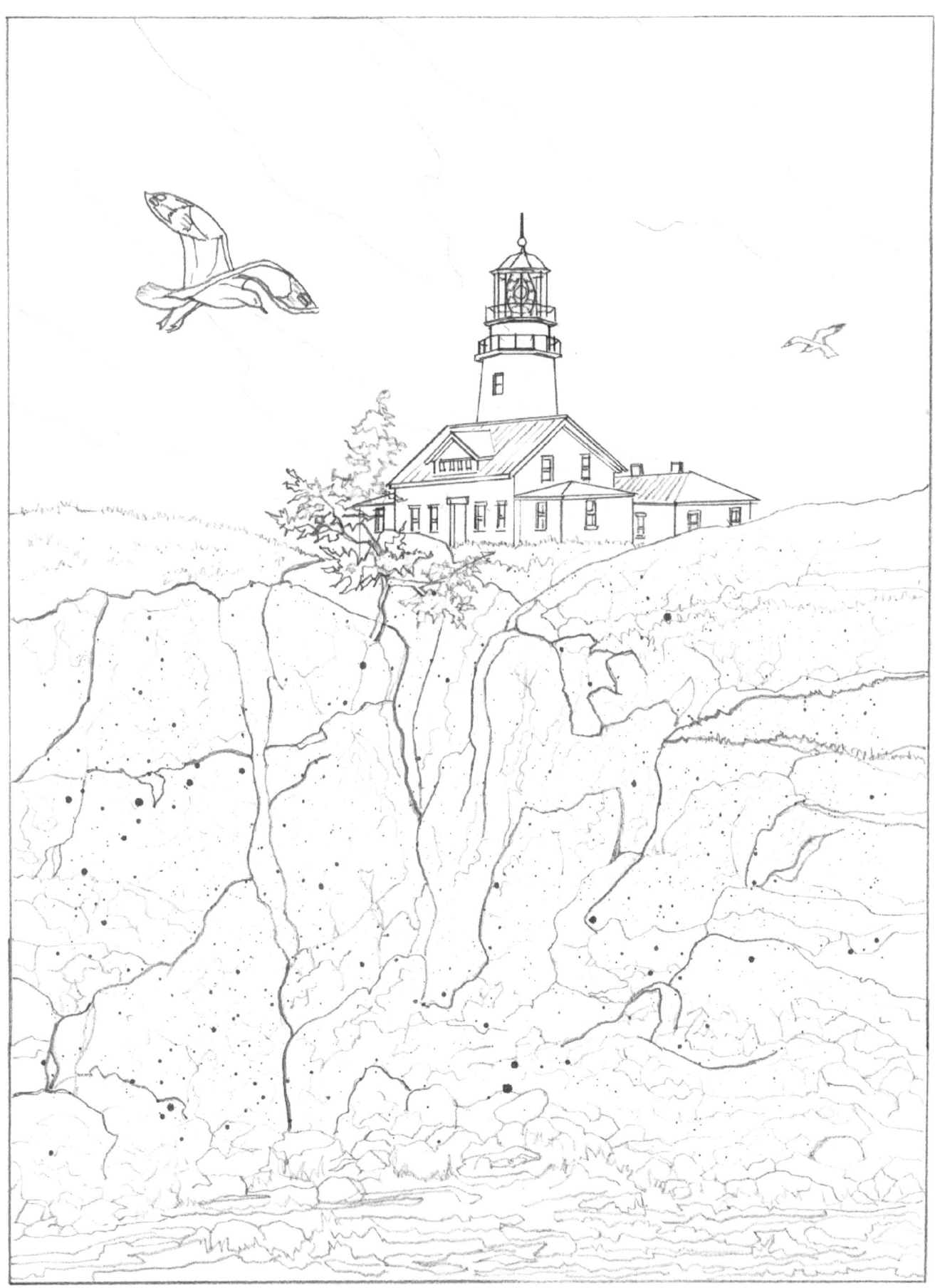
Cape Flattery - 13

Admiralty Head Lighthouse, built in 1903, replaced the original frame structure, which stood in the way of a planned gun placement at Fort Casey. The current masonry tower housed a fourth-order Fresnel lens, which was moved to the Dungeness Spit lighthouse in 1927, when shipping routes changed and made the light obsolete.

The station dwelling temporarily became an Army officer's residence. The lighthouse is now a museum and a tourist attraction of Fort Casey State Park on Whidbey Island, and is the headquarters for the Lighthouse Environmental Programs sponsored by the Washington State University. The structure and grounds are maintained by volunteers who also work in the gift shop and give tours to the many visitors who visit the lighthouse.

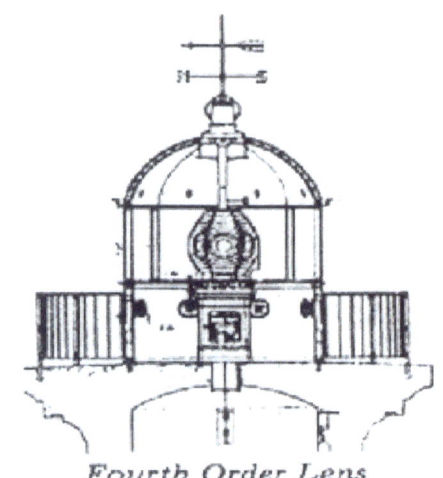

Fourth Order Lens

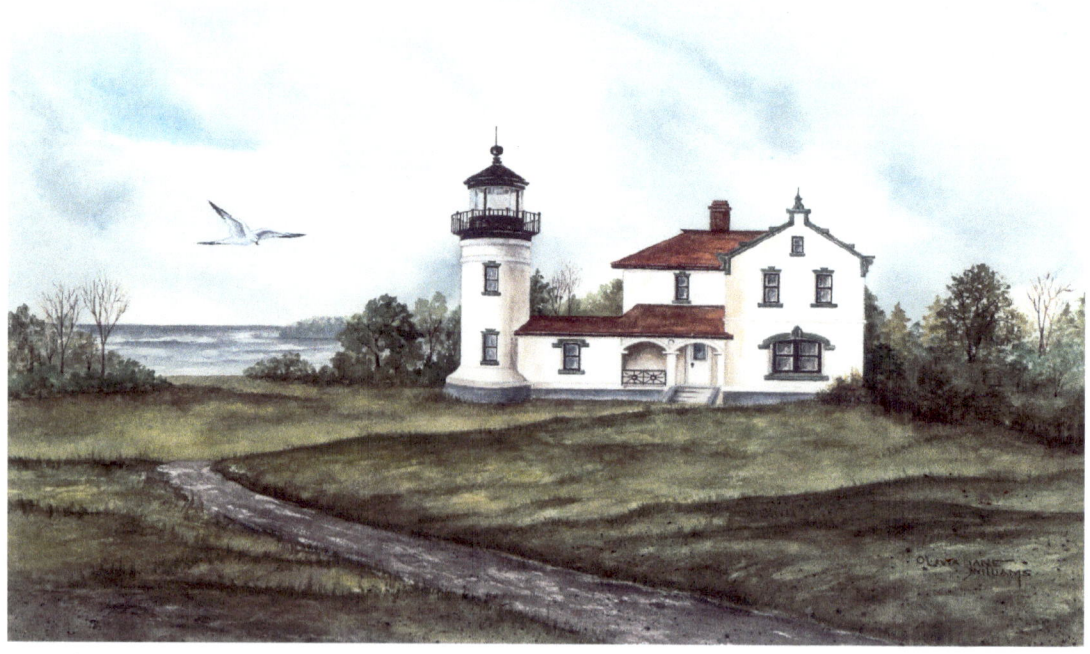

Admiralty Head - 15

Point No Point Lighthouse was constructed in 1879, but was first lit by a kerosene lamp hung from the dome of the lantern house on January 1, 1880. The fourth-order Fresnel lens arrived, but because of winter weather, not until February 1st were the glass panes delivered. A bell tower, with fog bell was installed nearby, and later a fog signal building was attached to the tower.

Located near Hansville on the Kitsap Peninsular, the lighthouse became an important navigational aid to ships entering and departing Puget Sound. It became an historic site where a thousand members of local Indian tribes signed a treaty with Gov. Issac Stevens, which ended the territory's Indian wars.

Point No Point is the headquarters for the U. S. Lighthouse Society.

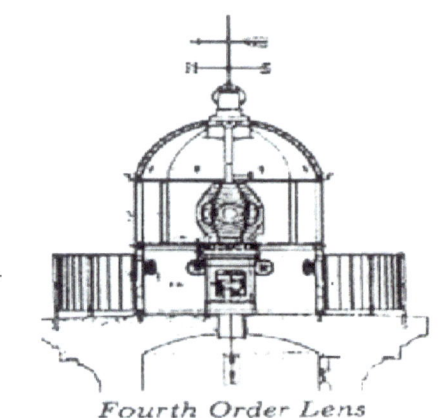

Fourth Order Lens

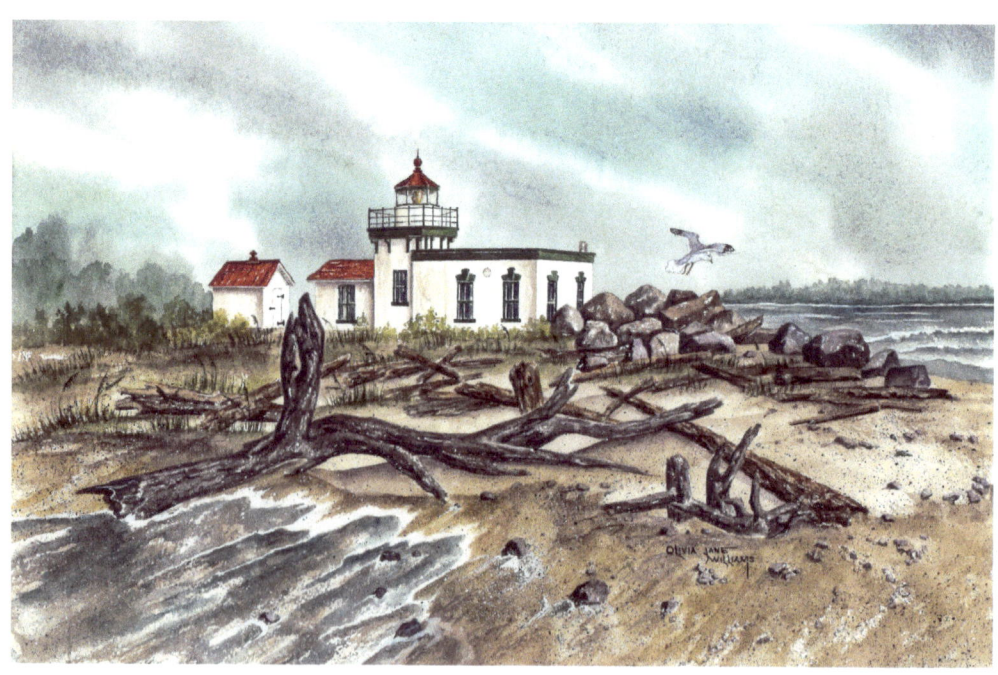

Point No Point - 17

North Head, located near Ilwaco, Washington, is considered one of the windiest places in the nation. Winds clocked at over 150 mph have flattened trees, fences and chimneys. When constructing the lighthouse, builders put hand rails on the windows so the keepers would have something to hold to while cleaning the glass.

Completed in 1898, the Norh Head lighthouse was built to warn ships approaching the Columbia River from the north. The large first-order Fresnel lens was taken from the Cape Disappointment lantern and installed in North Head. Cape Disappointment's lens was replaced with a fourth-order. Standing on a cliff almost 130 feet high, the sixty-five foot tower's light can be seen from a great distance.

In 1961 North Head was automated and the first-order lens shared by it and Cape Disappointment was moved to the Lewis and Clark Interpretive Center at nearby Fort Canby State Park.

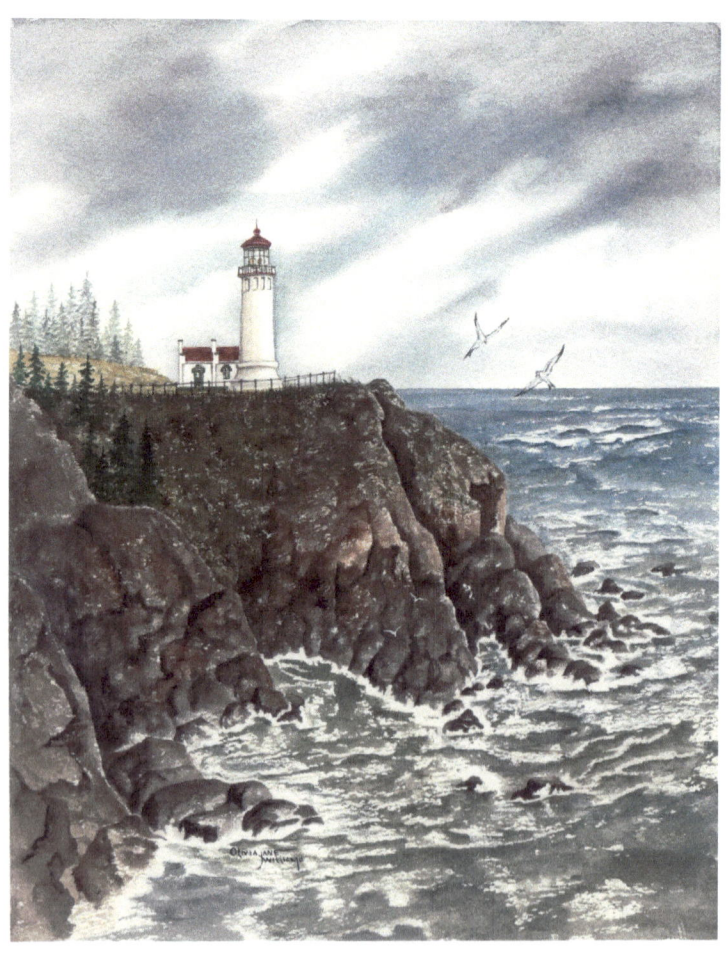

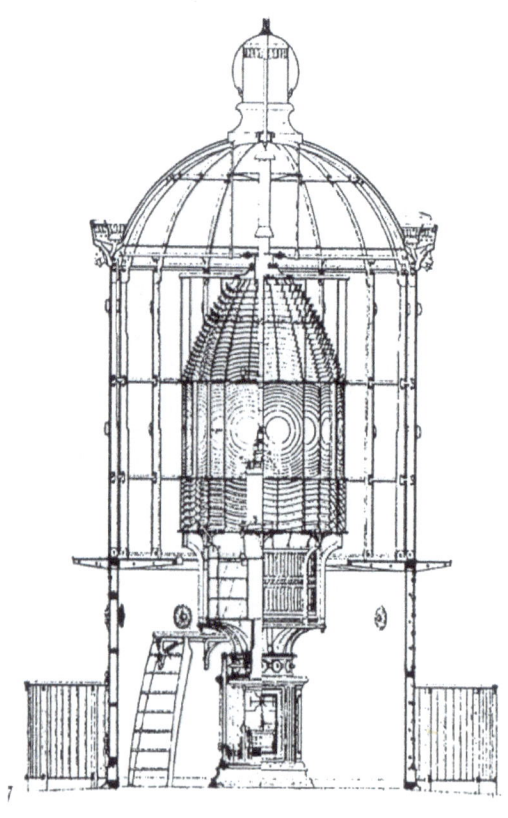

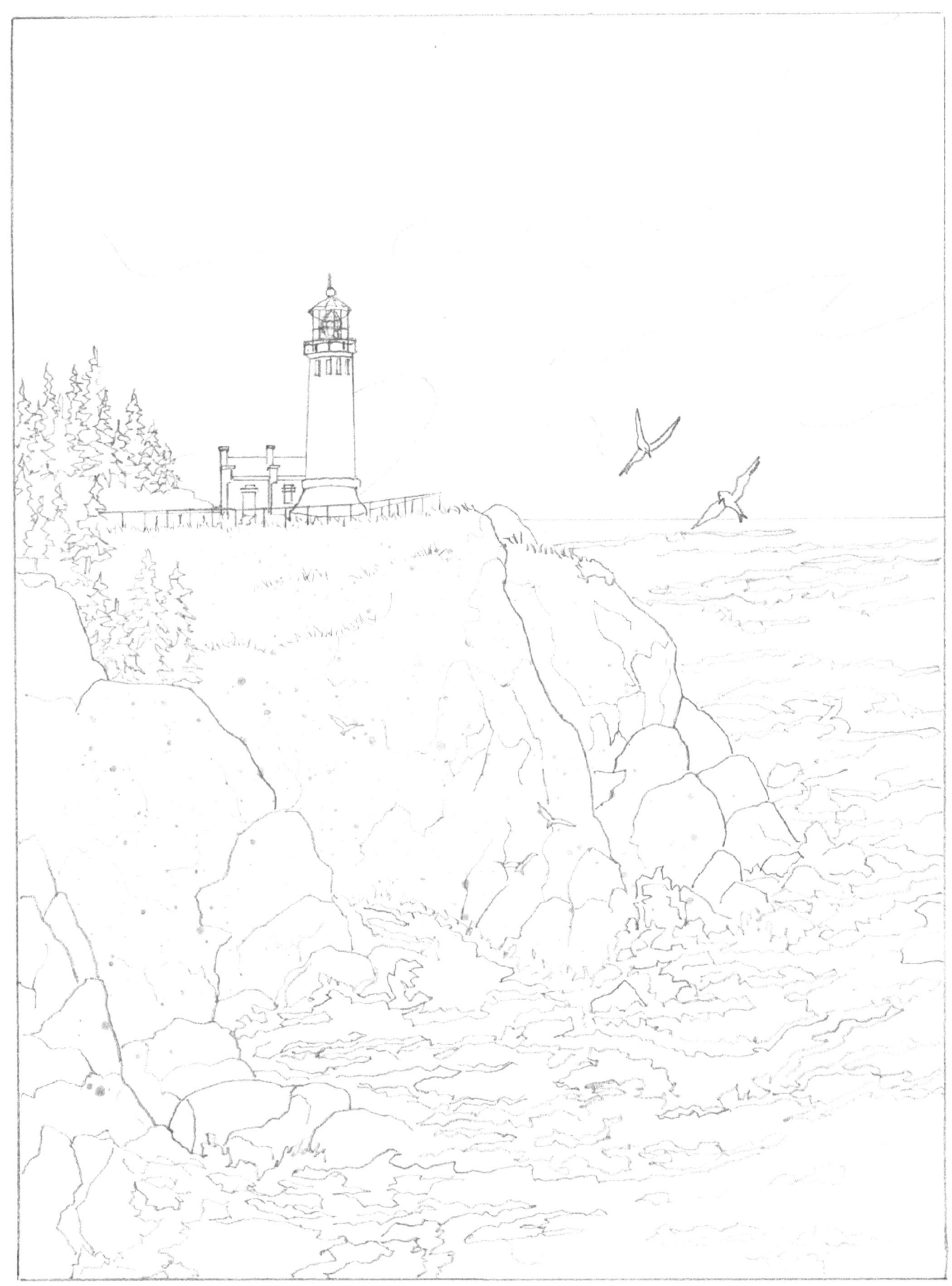

North Head - 19

Point Robinson, located at the eastern end of Maury Island, half way between Seattle and Tacoma, was established as a fog signal station in July, 1885. The current structure, a thirty-eight foot octagonal tower, built in 1915, was given a fifth-order lens, which guides sailing traffic through the narrow waters of Puget Sound.

There was always a waiting list for appointment to Point Robinson. The beautiful, forested island's close proximity to Seattle, also offered good hunting and fishing.

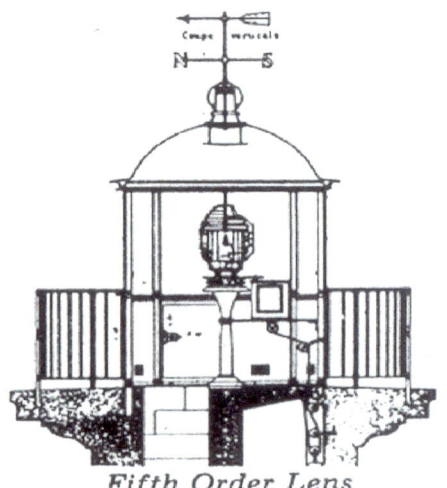
Fifth Order Lens

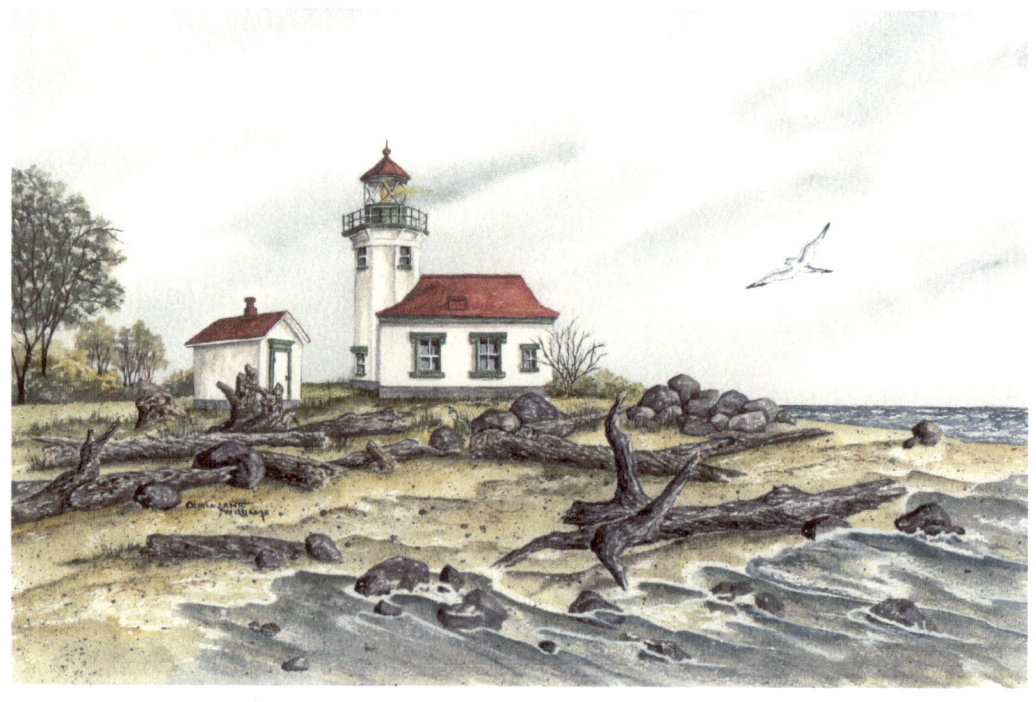

Point Robinson - 21

Browns Point's original lighthouse was constructed in 1887 and housed a lens lantern and fog bell. Although the lighthouse has been replaced, the original keeper's house was restored and remains as a guest house and gift shop.

The current structure was erected in 1933. It's thirty-one foot concrete tower sits at the west end of the entrance to Tacoma's Commencement Bay, a heavily traveled waterway for both commercial vessels and private boaters. The beacon light is the guardian of Port Tacoma's sea lanes. Today the station remains an outstanding place to watch tug boats and deep sea ships entering the busy portal.

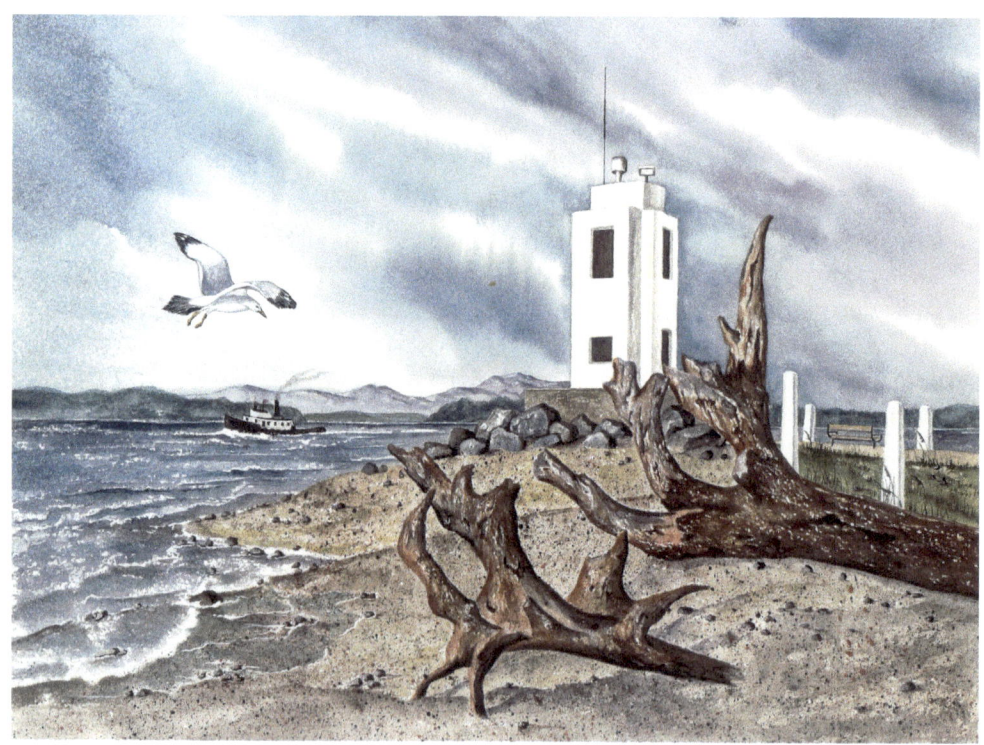

Browns Point - 23

Alki Point Lighthouse, completed in 1918, replaced the original light of 1887. The thirty-seven foot octagonal tower was given a fourth-order Fresnel lens and a special direction-finder calibration service was added later.

The lighthouse stands at the south entrance to Elliott Bay, near the location where Seattle's first settlers landed. With commerce increasing between Seattle and Tacoma, the lighthouse became a critical aid to navigation.

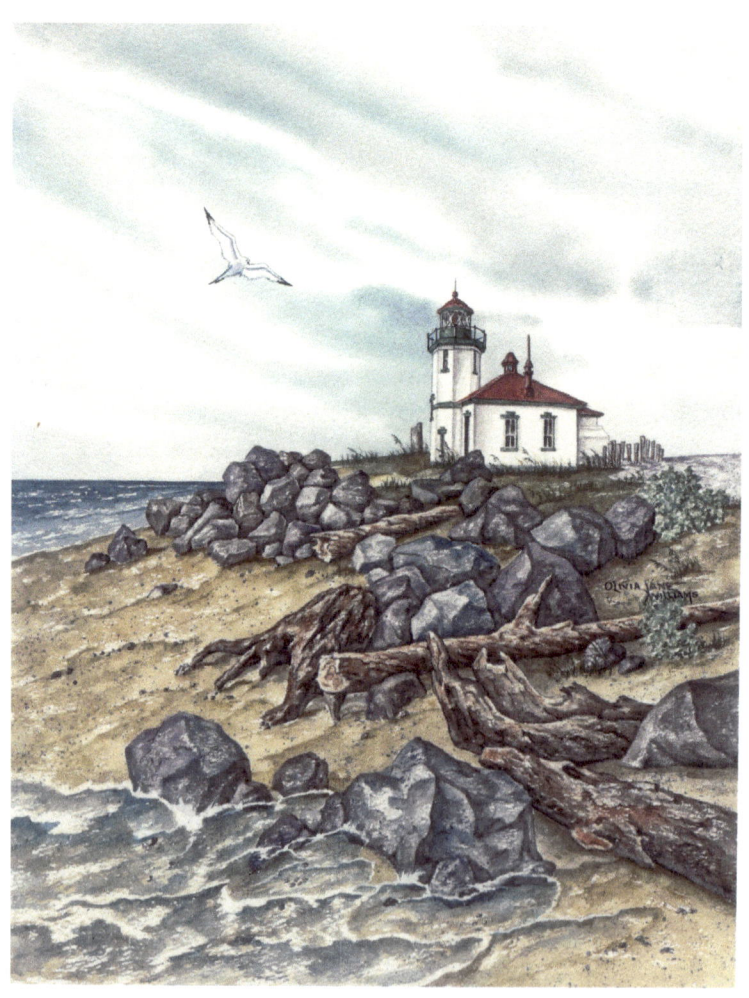

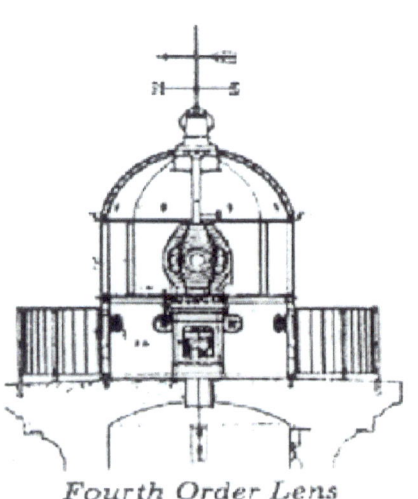

Fourth Order Lens

Alki Point - 25

Destruction Island lighthouse, stands 147 feet above sea level, on a 30 acre island, three miles off the Olympic Peninsula of Western Washington. After three years of construction, it was activated New Year's Eve 1891. The white, conical masonry tower has a 115 step spiral staircase and is ninety-four feet high, encased in iron plates. The lantern housed a first-order Fresnel lens with 1,176 glass prisms, including twenty-four bulls-eyes, casting its light on all points of the horizon.

The lighthouse can be seen from Highway 101, about a mile south of Ruby Beach, between La Push and Kalaloch. Its lens is on display at the Westport Maritime Museum in Westport.

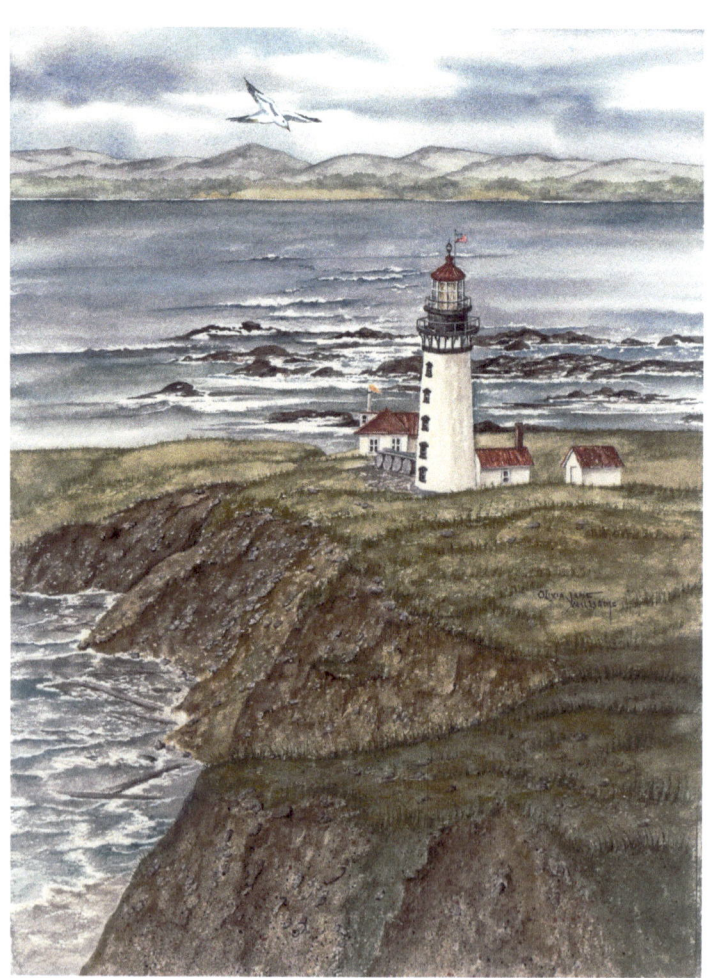

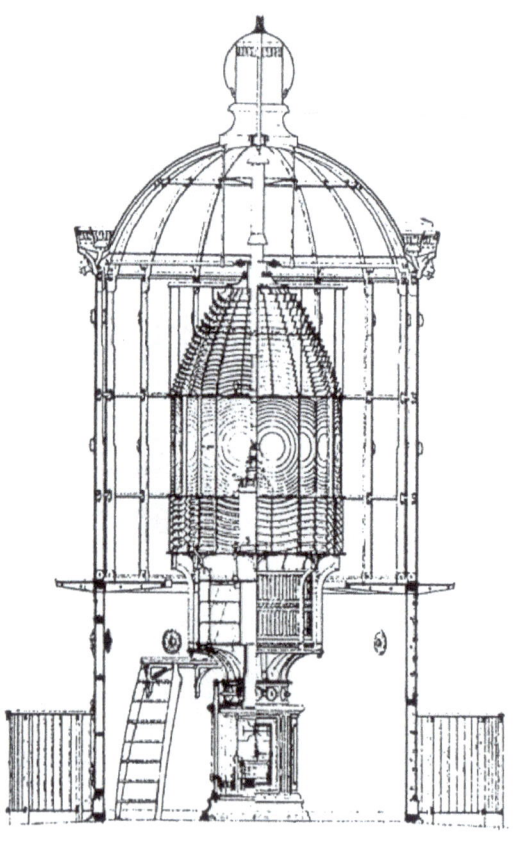

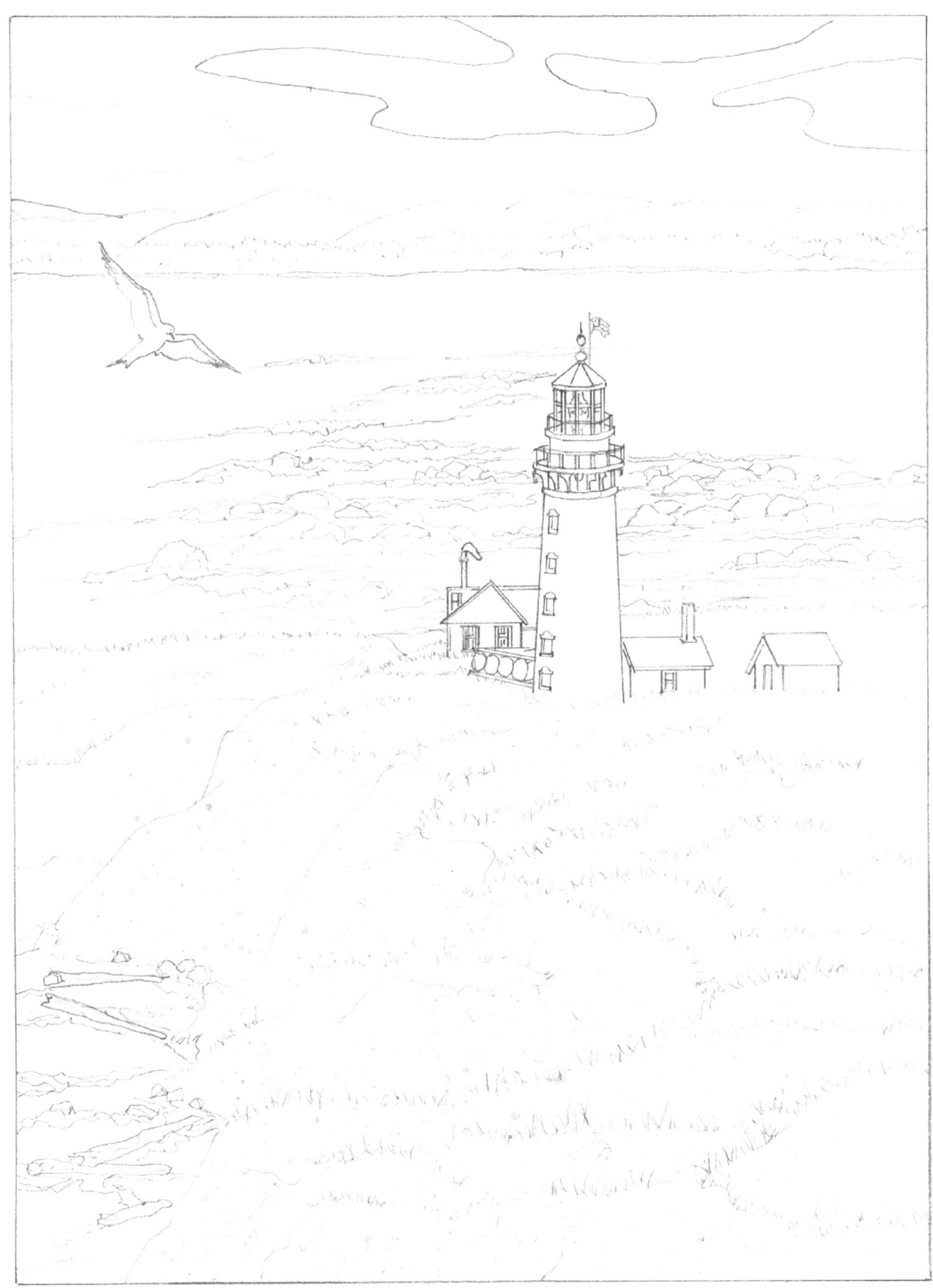

Destruction Island - 27

Grays Harbor Lighthouse, located near Westport, was completed in 1898, and is the tallest on the West Coast. It's octagonal masonry structure stands 107 feet from base to lantern and houses a third-order Fresnel lens with three bulls eyes, 8 inches in diameter. Near the lighthouse, a fog signal and radio beacon are maintained to aid commercial fishing vessels and deep-sea cargo ships entering and departing the harbor.

Due to high water and erosion, a jetty was built to protect the lighthouse and surrounding area, which filled with sand and separated the lighthouse from the sea.

The lighthouse is part of the Westport Maritime Museum and open for tours.

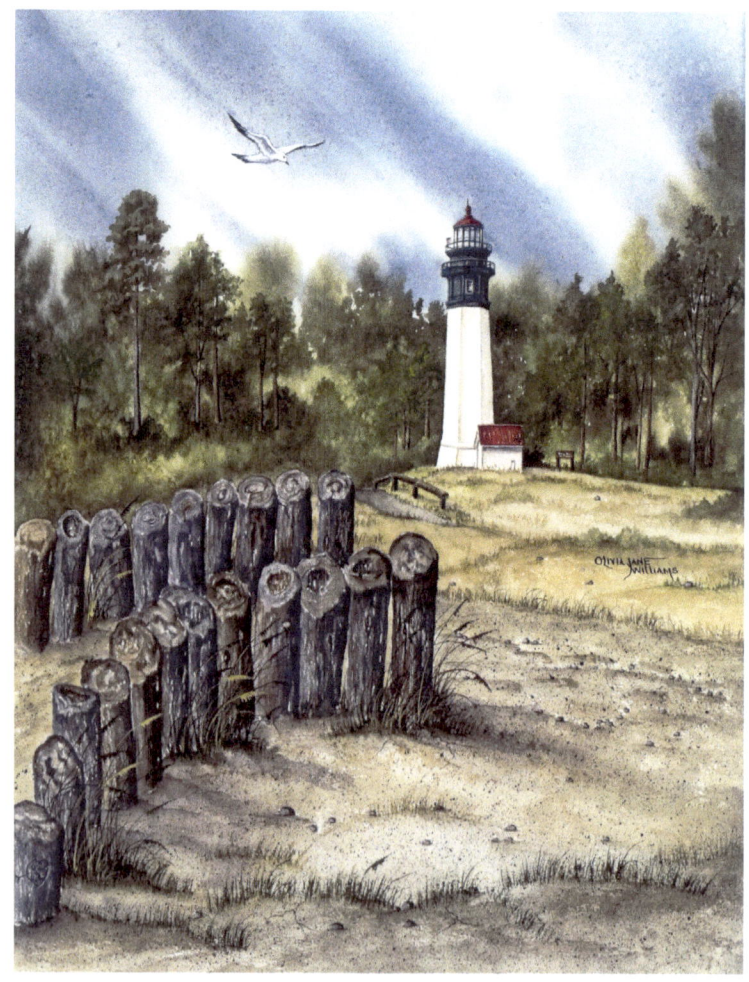

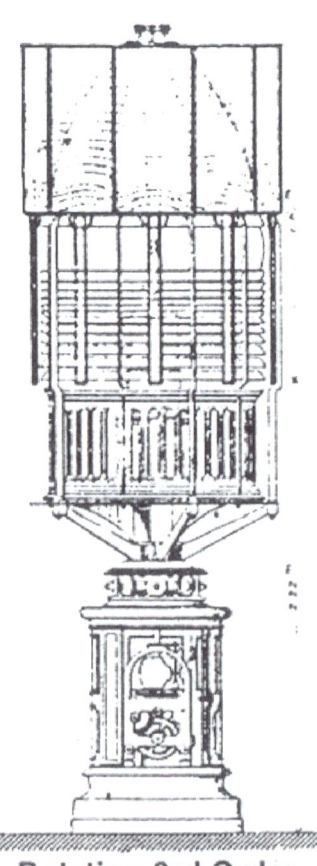

Rotating 3rd Order

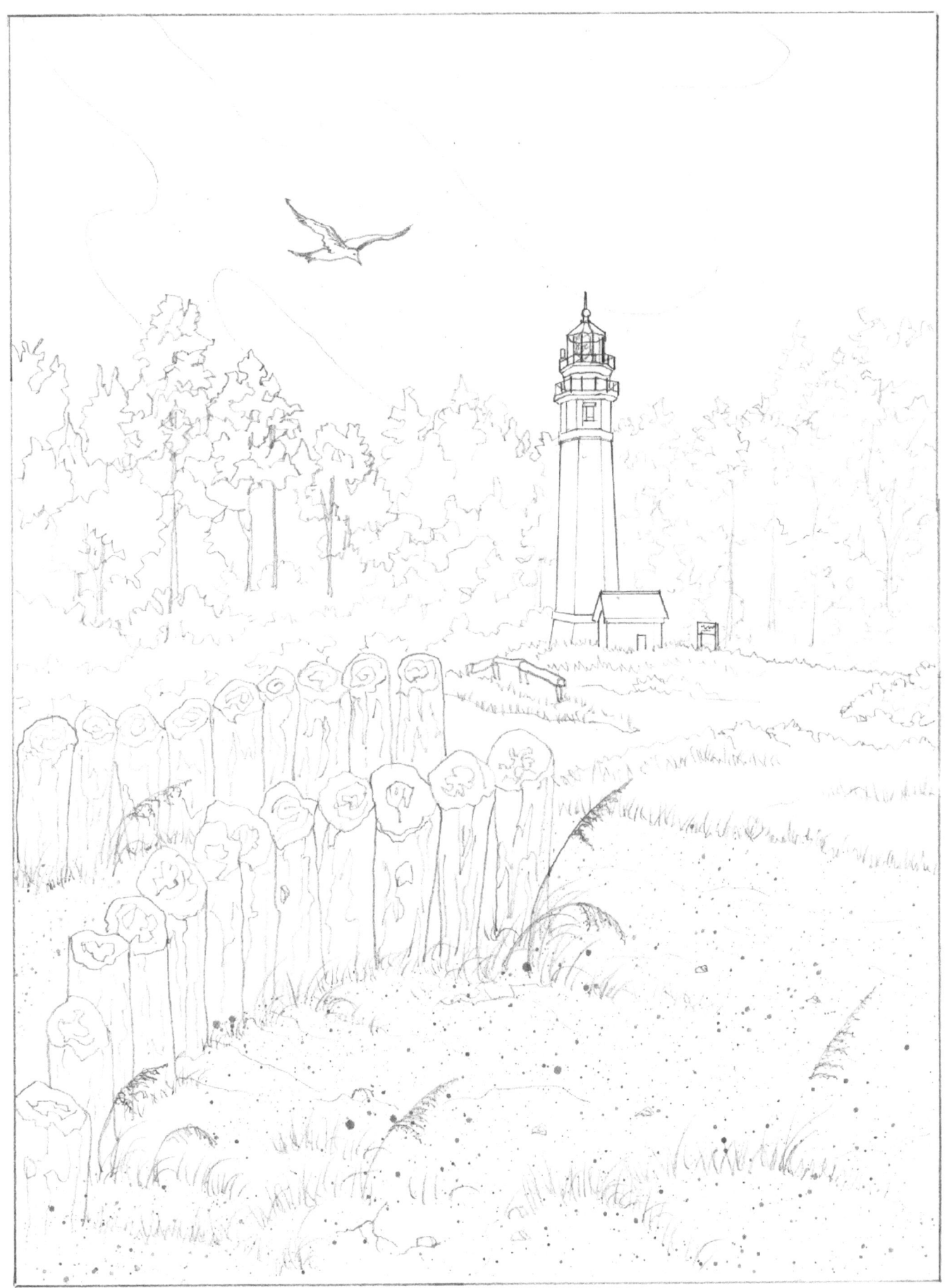

Grays Harbor - 29

West Point Lighthouse, a landmark since November 1881, sits at the north entrance to Seattle's Discovery Bay, at the foot of Magnolia Bluff, in Discovery Park. The masonry tower stands only twenty-three feet and houses a fourth-order Fresnel lens. It's white beam is visible fifteen miles away. Countless vessels pass the sentinel daily, and it's considered Seattle's welcoming light.

Fourth Order Lens

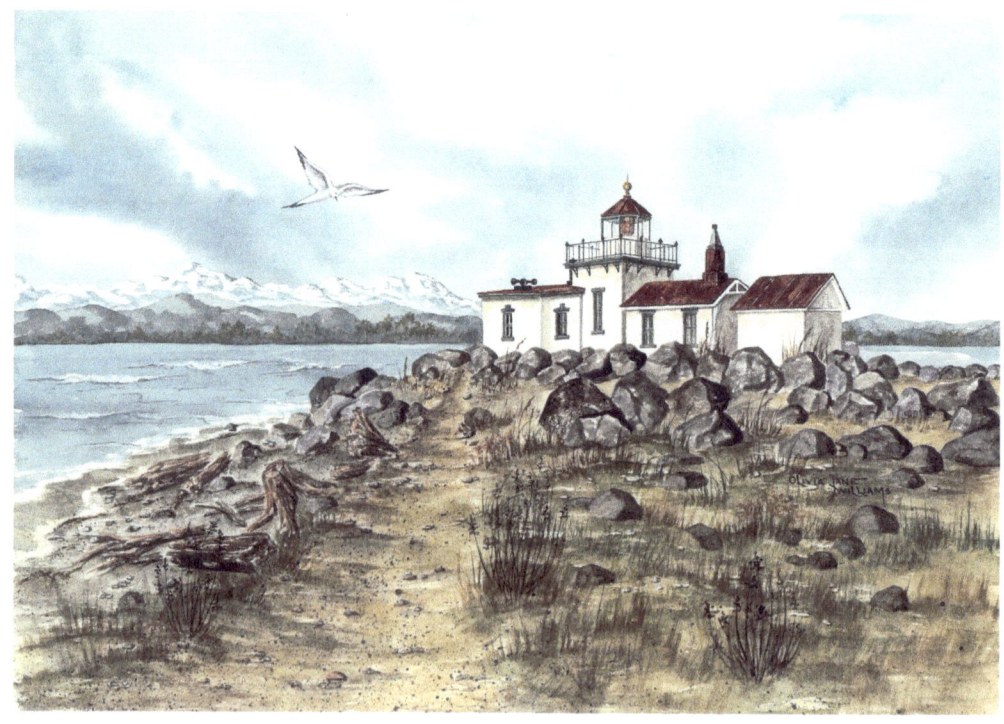

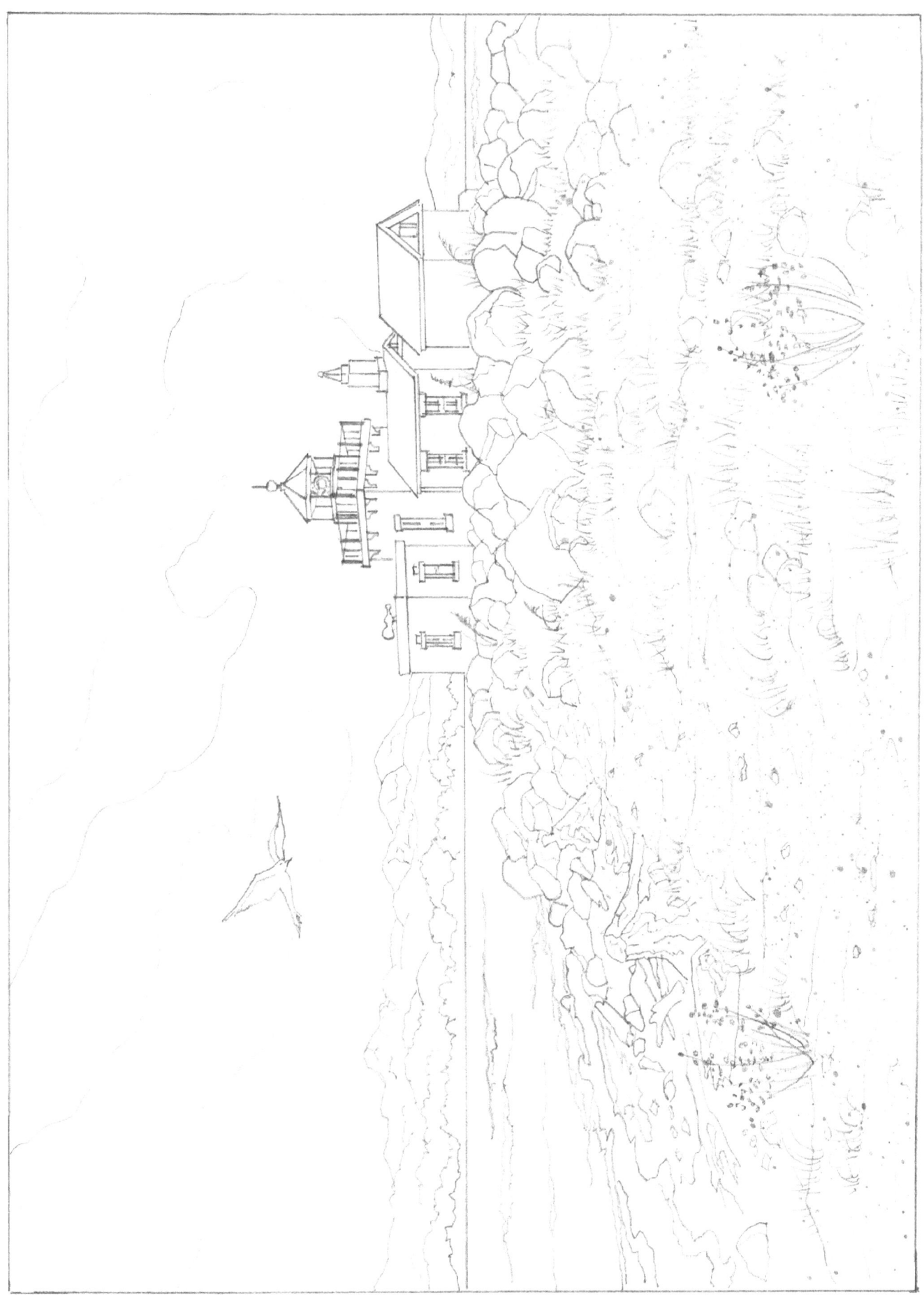
West Point Seattle - 31

Mukilteo lighthouse, active since 1906, is located near the Whidbey Island ferry landing in Mukilteo, overlooking Possession Sound. The thirty-foot, octagonal, Victorian style, wood frame structure, was given a fourth-order Fresnel lens and a daboll trumpet to warn ships during heavy fog.

In 1855, on the grounds where the lighthouse stands, a treaty was signed between Gov. Issac Stevens and the Northwestern Indian Chiefs ceding all lands from Pully Point northward to the whites.

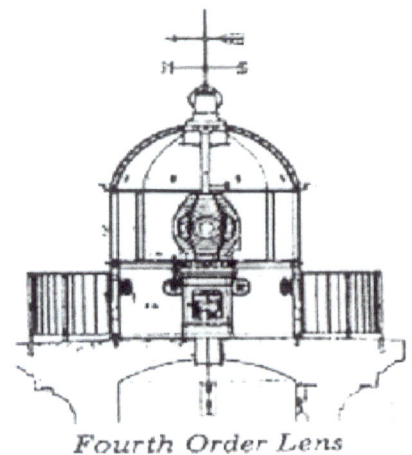
Fourth Order Lens

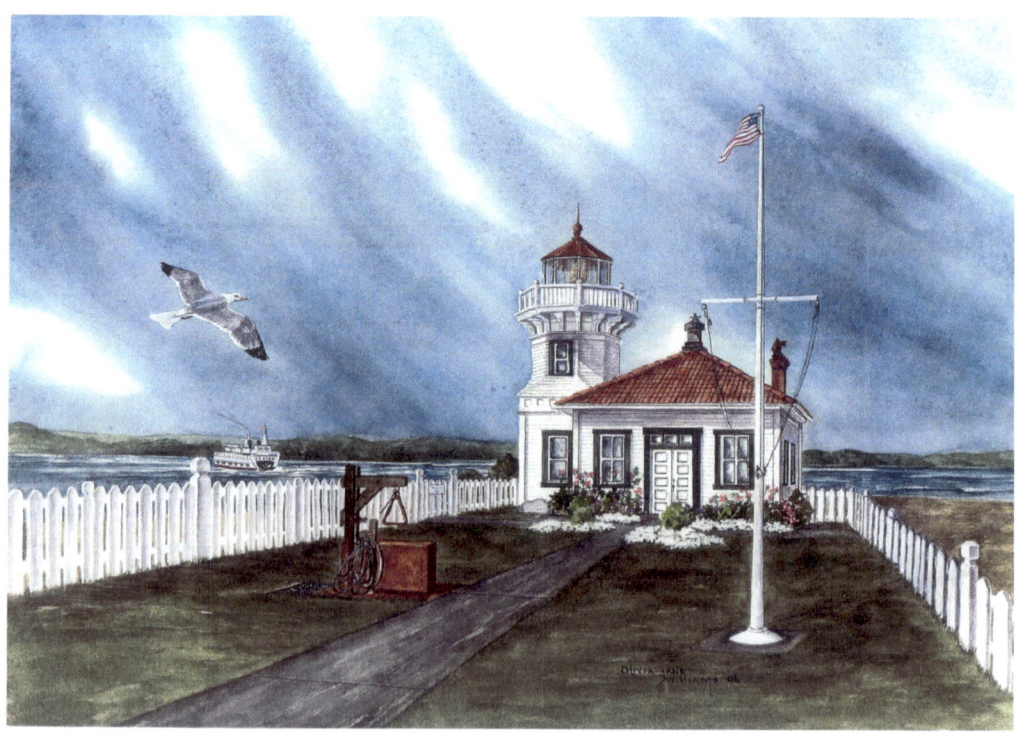

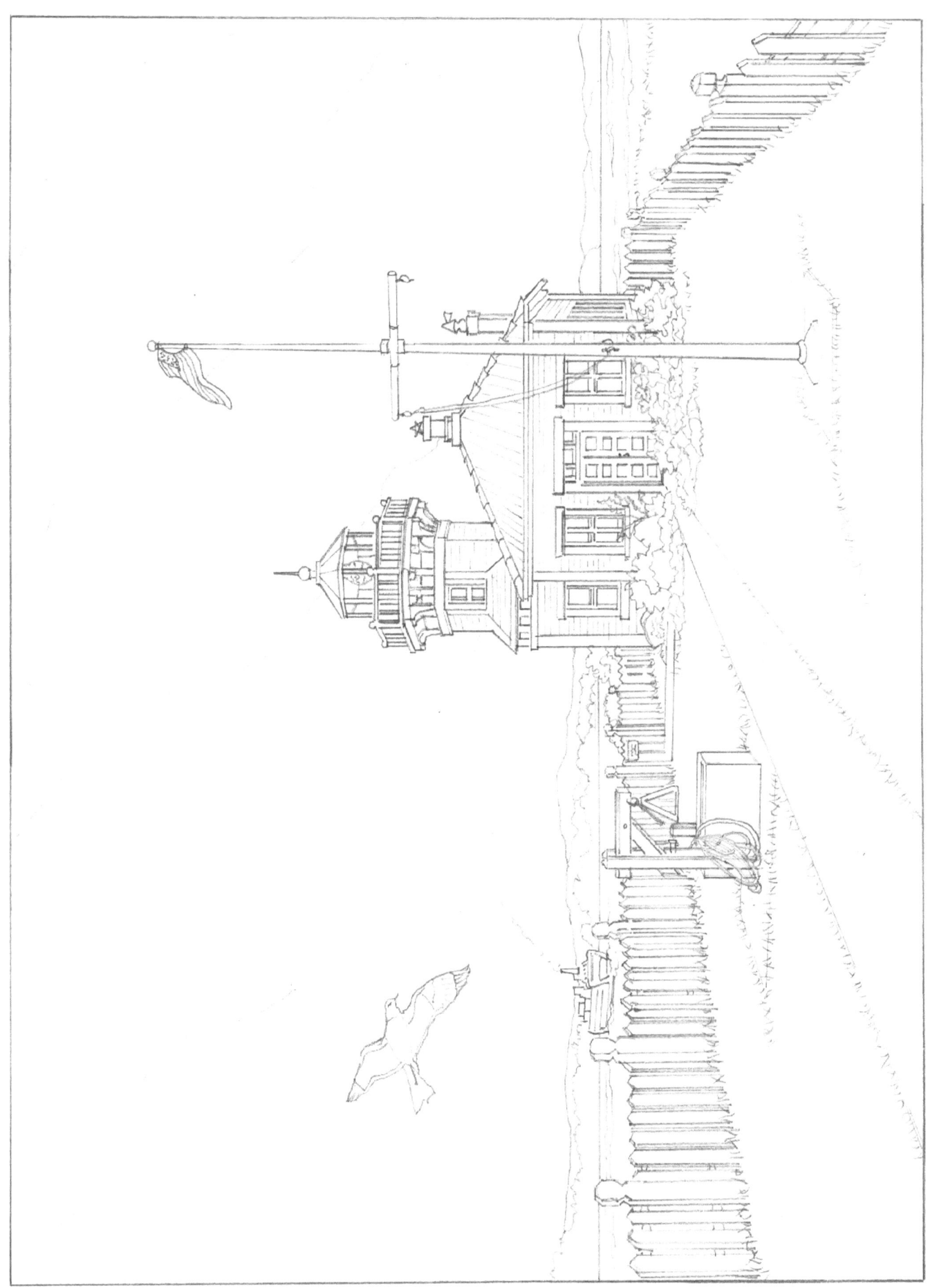

Mukilteo - 33

Point Wilson Lighthouse, located in Fort Worden State Park near Port Townsend, was completed and lighted in 1914, replacing the original 1879 structure, which was threatened by high tides and erosion. Constructed of reinforced concrete, the forty-six foot octagonal tower was designed to reduce wind pressure on the building. The new lantern housed a fourth-order Fresnel lens that focused the light, visible from 270 degrees of horizon.

Vessels leaving the Strait of Juan de Fuca and entering Admiralty Inlet are greeted by the guiding light of Point Wilson and a majestic view of Mt. Baker. At the turn of the century, three forts were created to protect Puget Sound, Fort Worden, Fort Casey on Whidbey Island and Fort Flagler at Marrowstone Point.

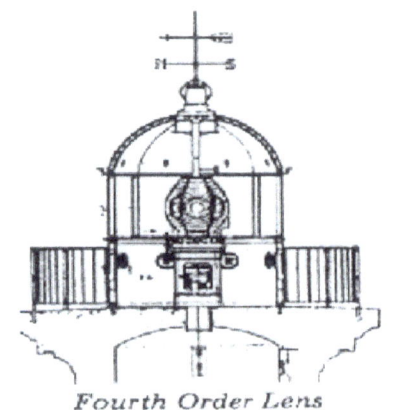

Fourth Order Lens

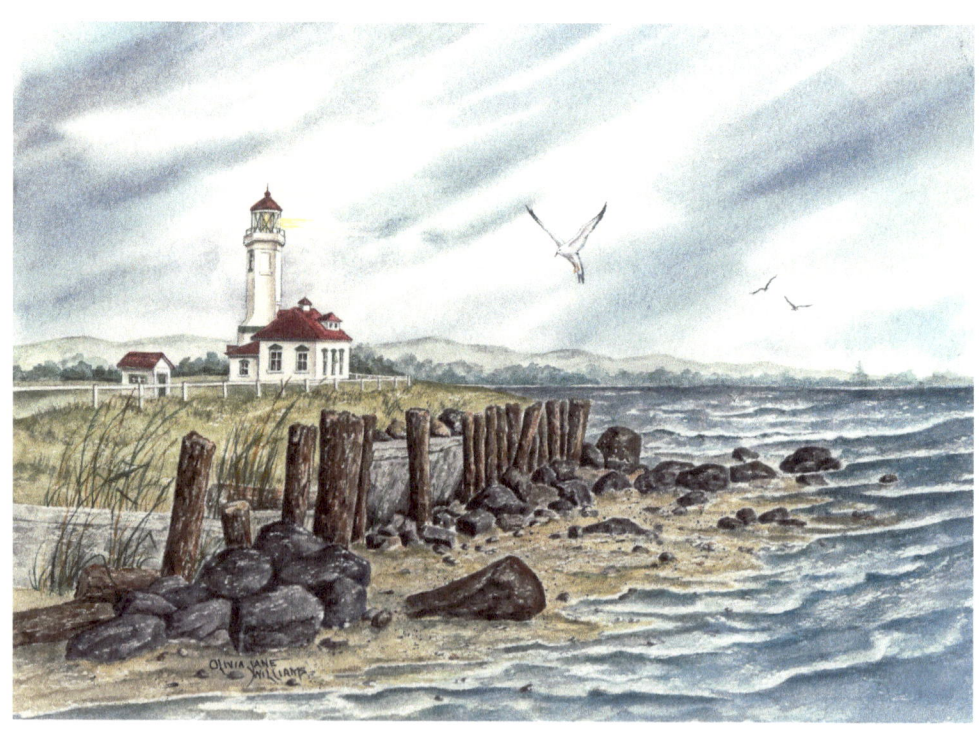

Point Wilson - 35

Lime Kiln Lighthouse, built on San Juan Island in 1914, features a thirty-eight foot octagonal tower with a fourth-order Fresnel lens, and is attached to a fog signal building. It's tower faces the major shipping channel west of the island, and marks the key channel through Haro Strait.

The lighthouse gets it's name from the lime rock cliffs and once productive lime kilns. It was the last major lighthouse in the state to receive electricity. Oil vapor lamps in prismatic lens provided the light source until WWII, due to the cost of extending an underwater cable from the mainland. Lime Kiln is now a favorite site for whale watching.

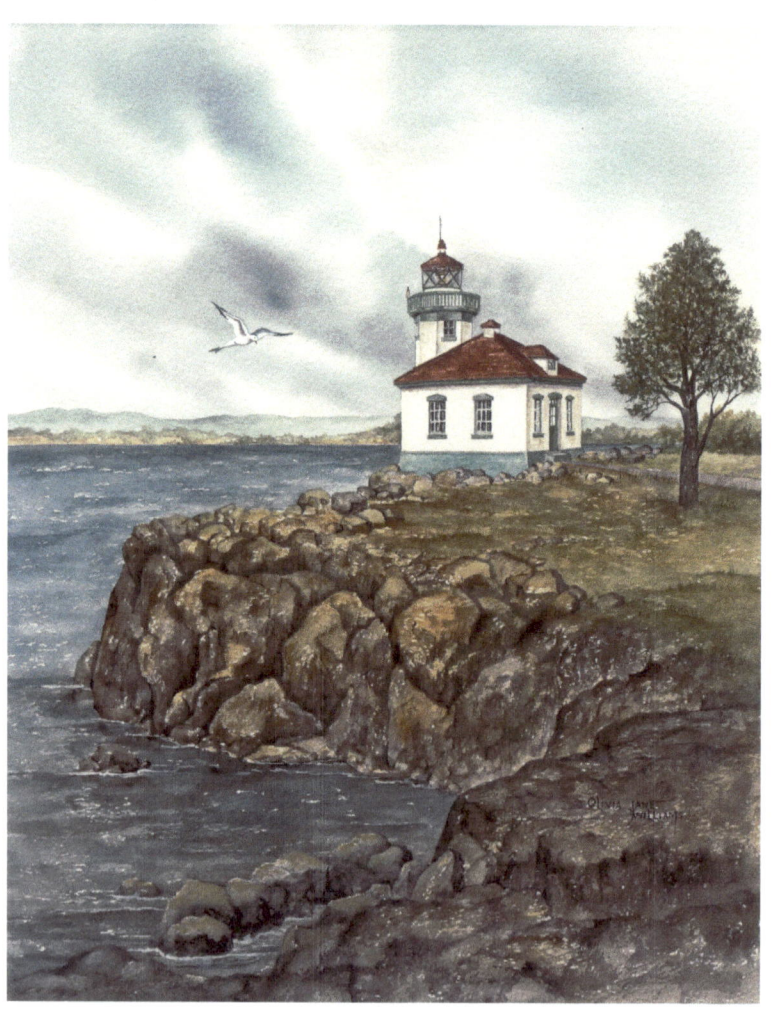

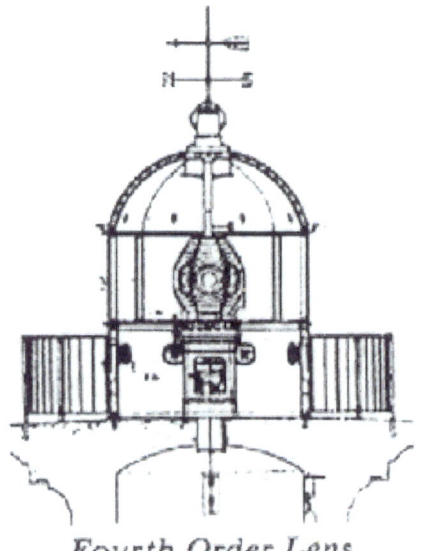

Fourth Order Lens

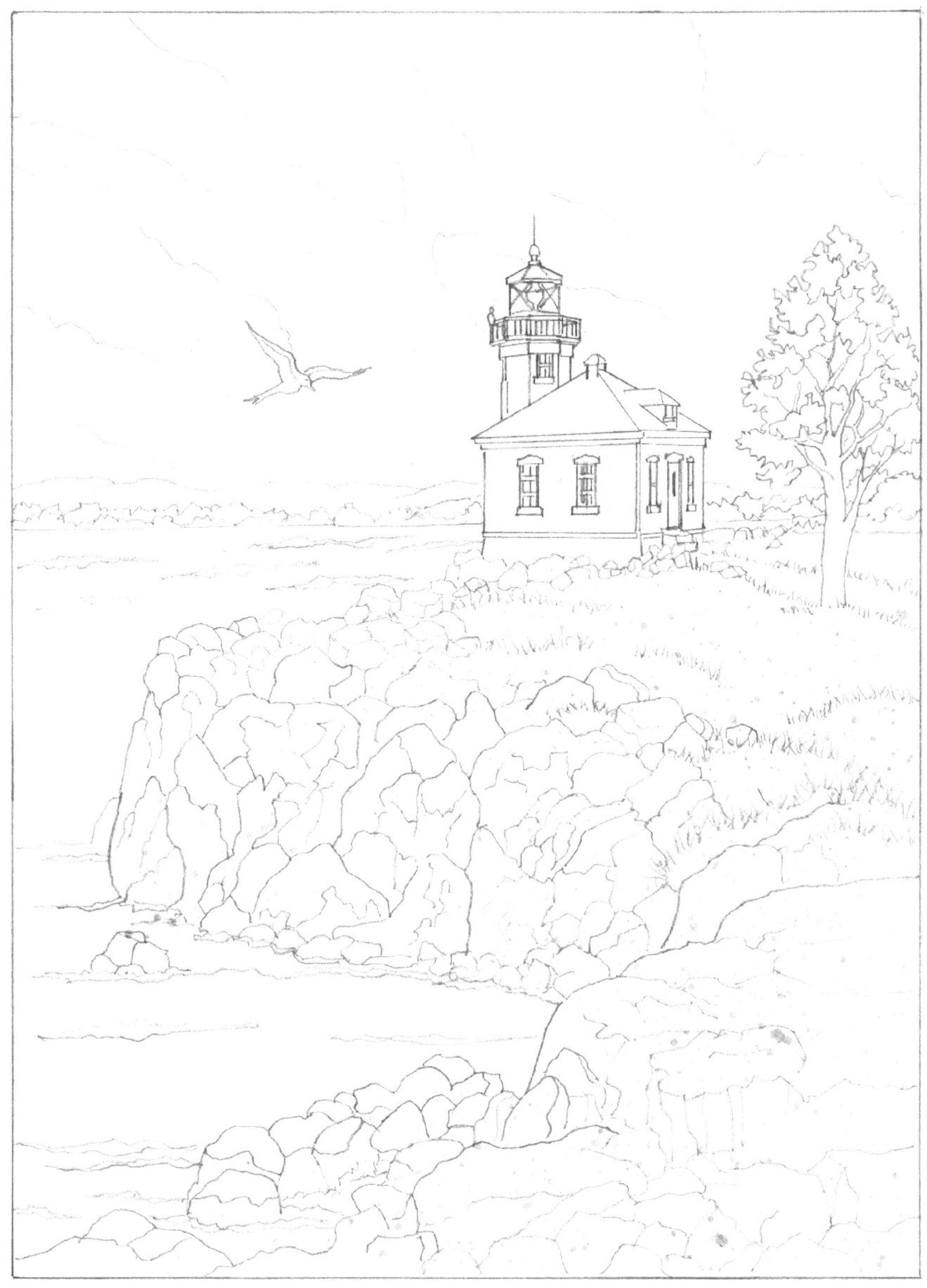

Lime Kiln - 37

Gig Harbor Lighthouse, completed in October, 1988, was built by the Gig Harbor Lighthouse Association. The association was formed by a group of local residents who saw the need for a navigation aid to serve the boating community and fishing industry. The sixteen foot, concrete, octagonal tower has four mock portholes on its sloping sides and is capped by a copper and brass cupola. Its red flashing optic, battery operated, marks the entrance to the harbor.

As a fund raising project for the construction of the lighthouse, the Association sold 'time-capsules', which were filled with news articles, photos, etc., by the buyer. The sixteen inch cylinders were sealed in the lighthouse for twenty-five years, until their opening.

In 1989, the lighthouse was dedicated and approved by the Coast Guard as an official private aid to navigation.

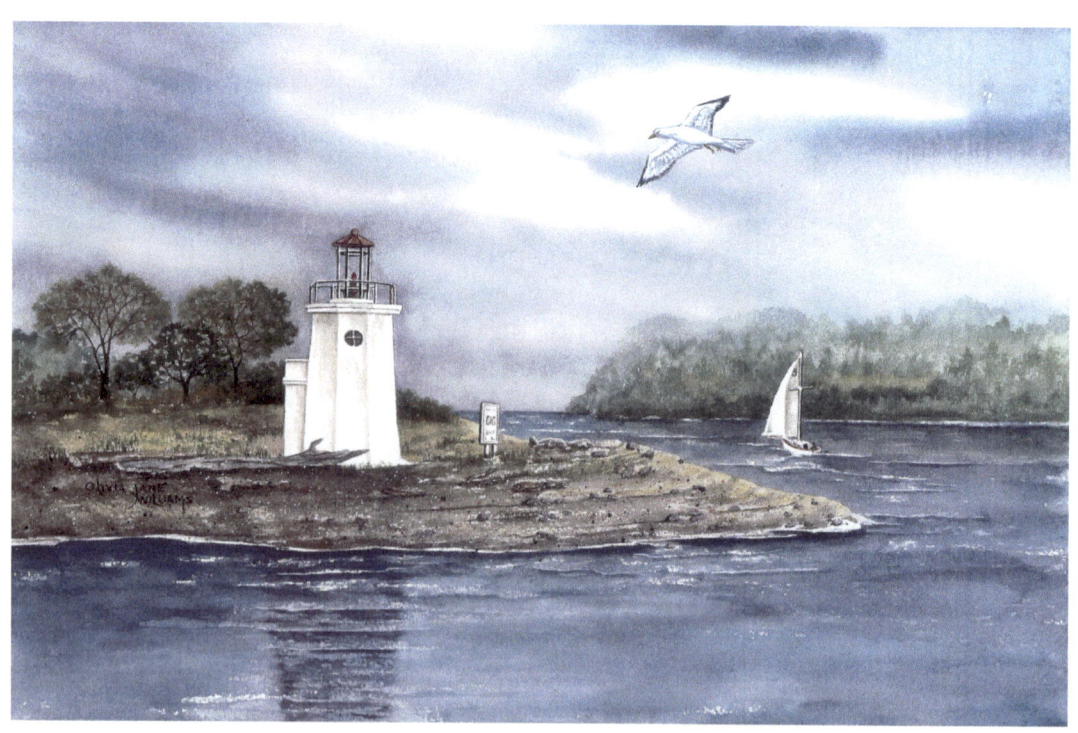

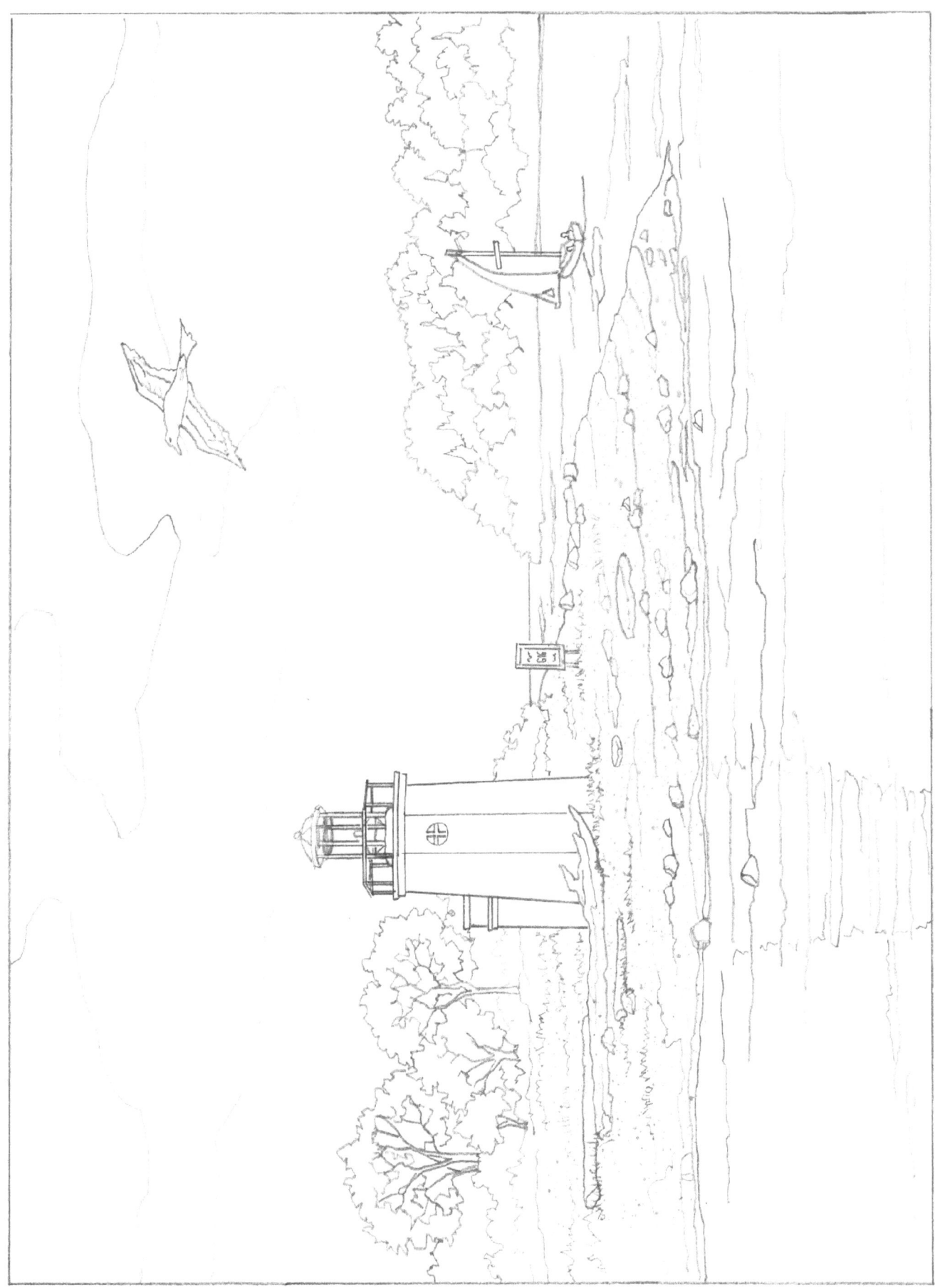

Gig Harbor - 39

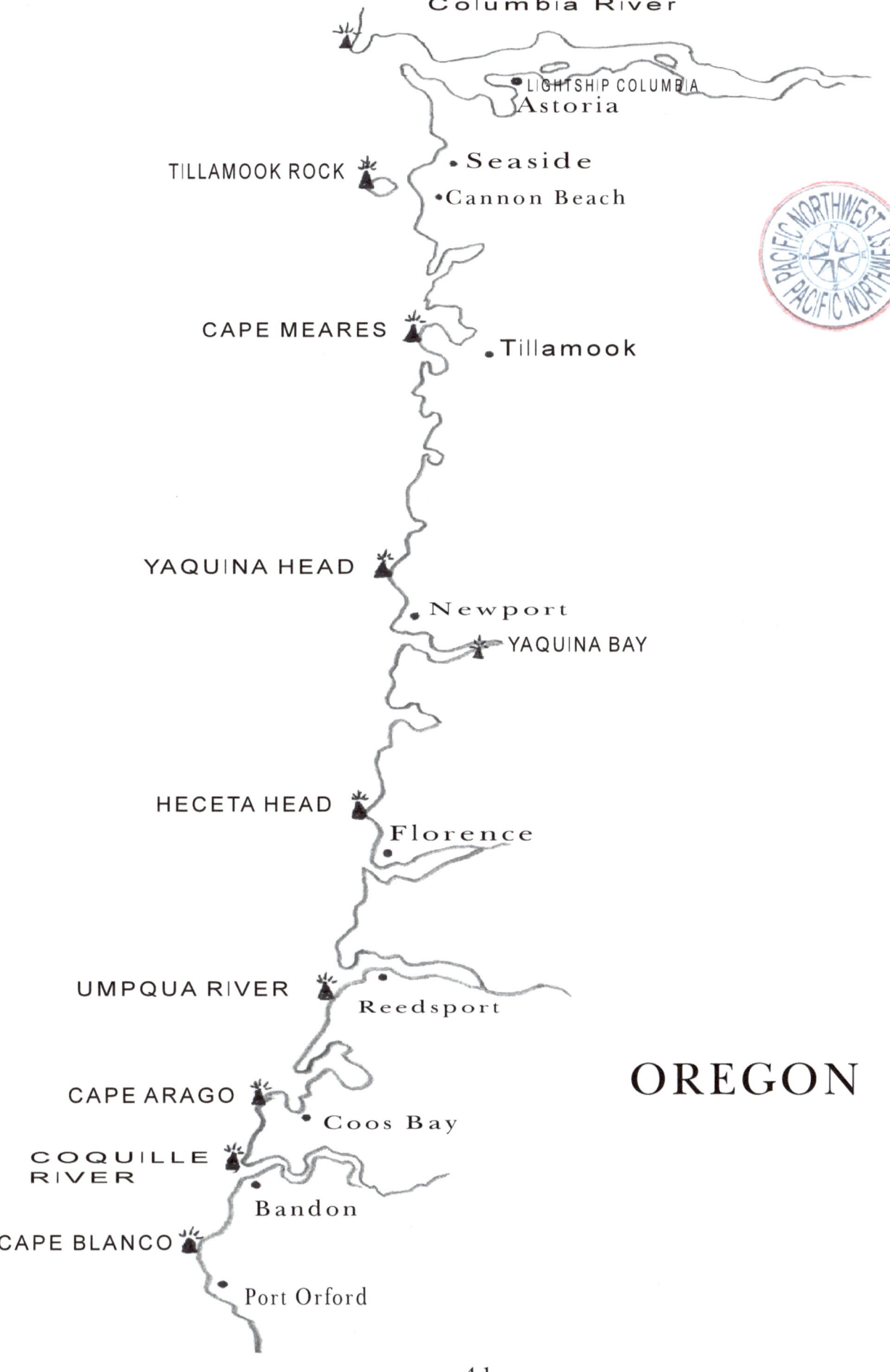

Tillamook Lighthouse, located 20 miles south of the Columbia River, and more than a mile off shore, was completed in 1881. Construction of the lighthouse was considered an engineering fete and many lives were lost during it's building.

The stone structure was fitted with a first-order Fresnel lens that shined almost continuously for seventy-six years. In 1957, the light was extinguished when the lighthouse was replaced by a buoy. The building now serves as a columbarium.

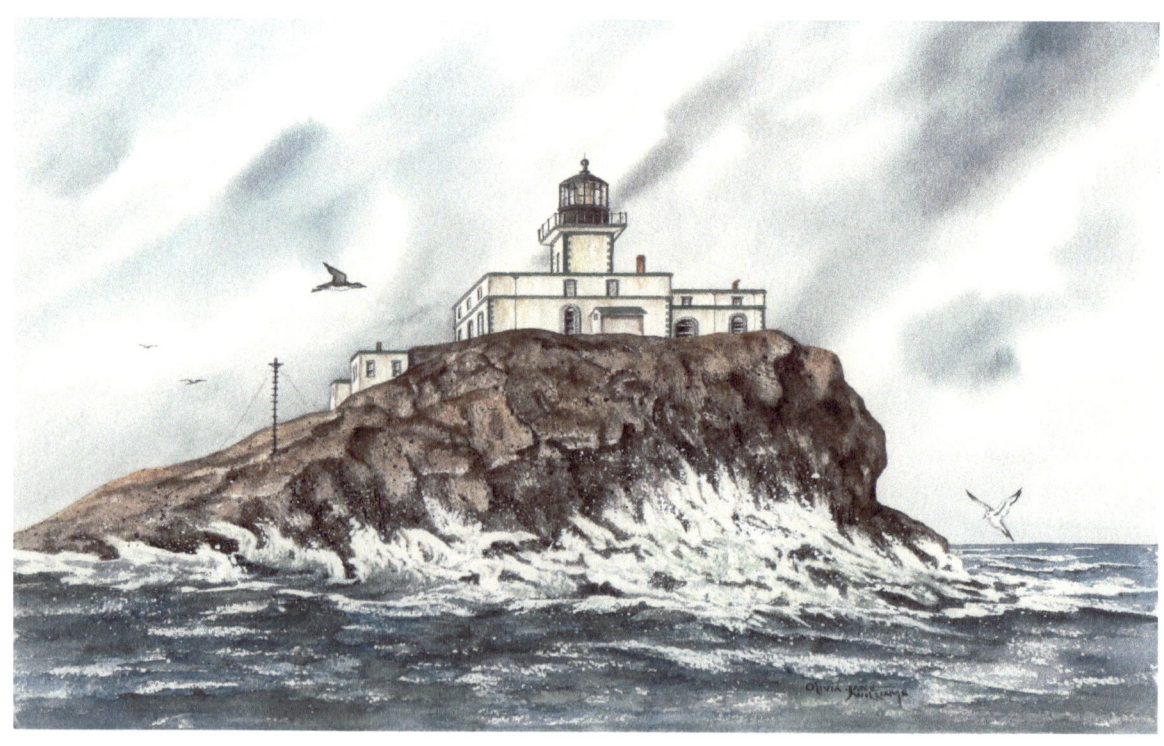

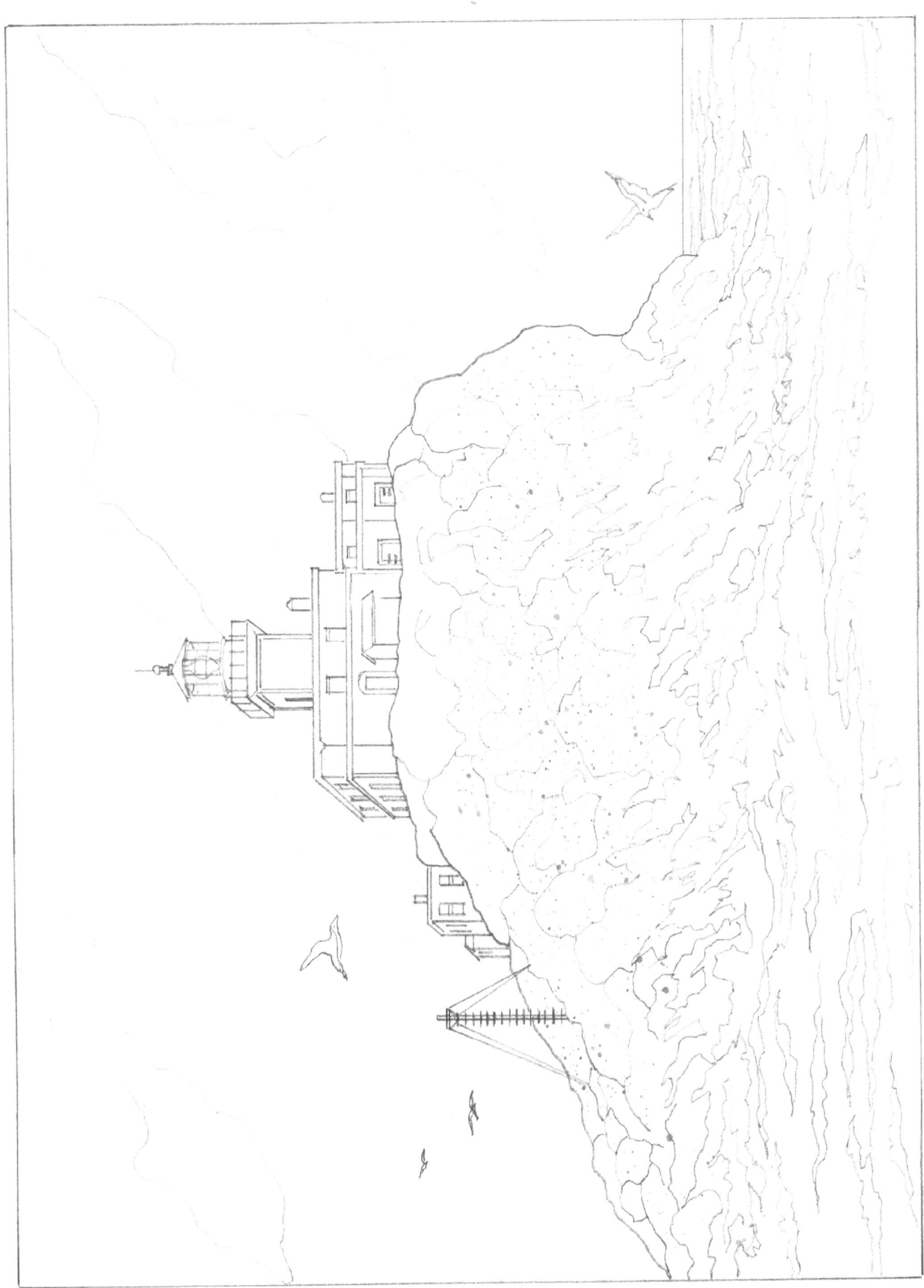

Tillamook Rock - 43

Cape Meares Lighthouse, established in 1890, is located several miles west of Tillamook. The thirty-eight foot octagonal, iron tower stands on a towering cliff 232 feet above the Pacific Ocean to warn ships of the hazardous bar at the bay's entrance. The lantern was given a first-order Fresnel lens, illuminated by a five-wick coal-oil lamp, which made the light visible from twenty-one miles at sea.

Oregon built a state park around the lighthouse reservation, and local volunteers maintain the structure and grounds. Nearby is **Cape Meares National Refuge**, a popular tourist attraction.

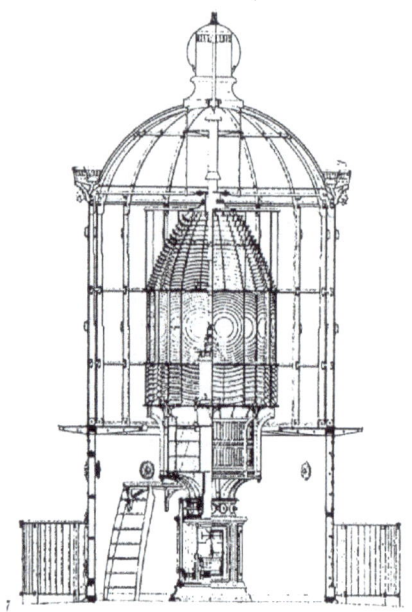

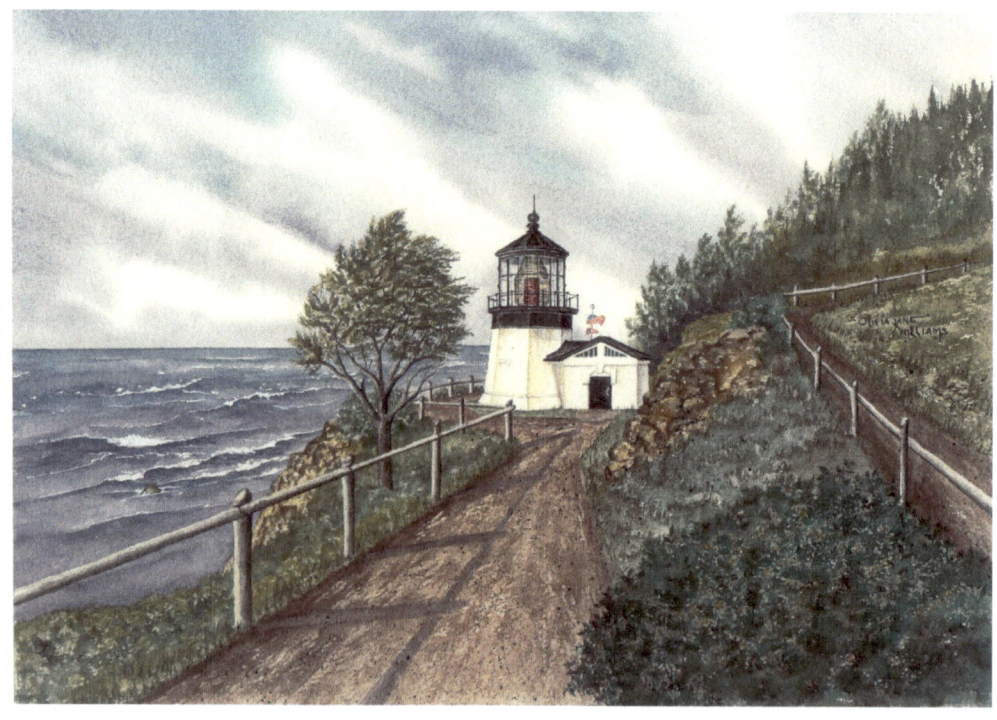

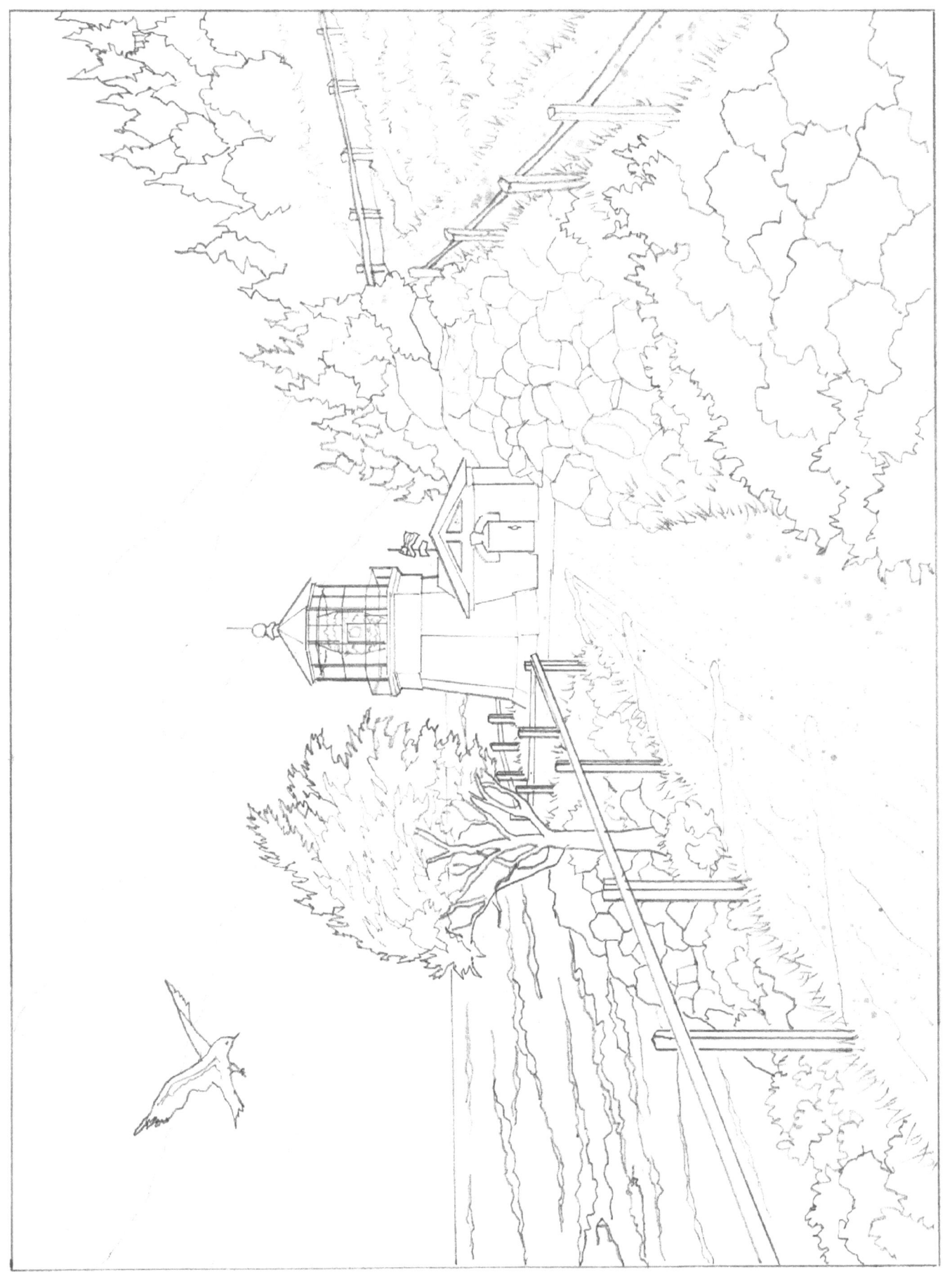
Cape Meares - 45

Yaquina Head Lighthouse, located north of Newport, sits on a core of magnatized iron that affects compasses of ships nearby. The ninety-three foot masonry tower was equipped with a fixed first-order lens that casts a beam visible nineteen miles at sea. Its lamp was illuminated on August 20, 1873 and has continued to shine since that time. The tower's spiral staircase sits on a marble floored rotunda below 114 steps leading to the lantern.

The lighthouse has been featured in many publications and is a favorite of photographers and artists. Tourist enjoy the observation deck overlooking rocky tide pools below.

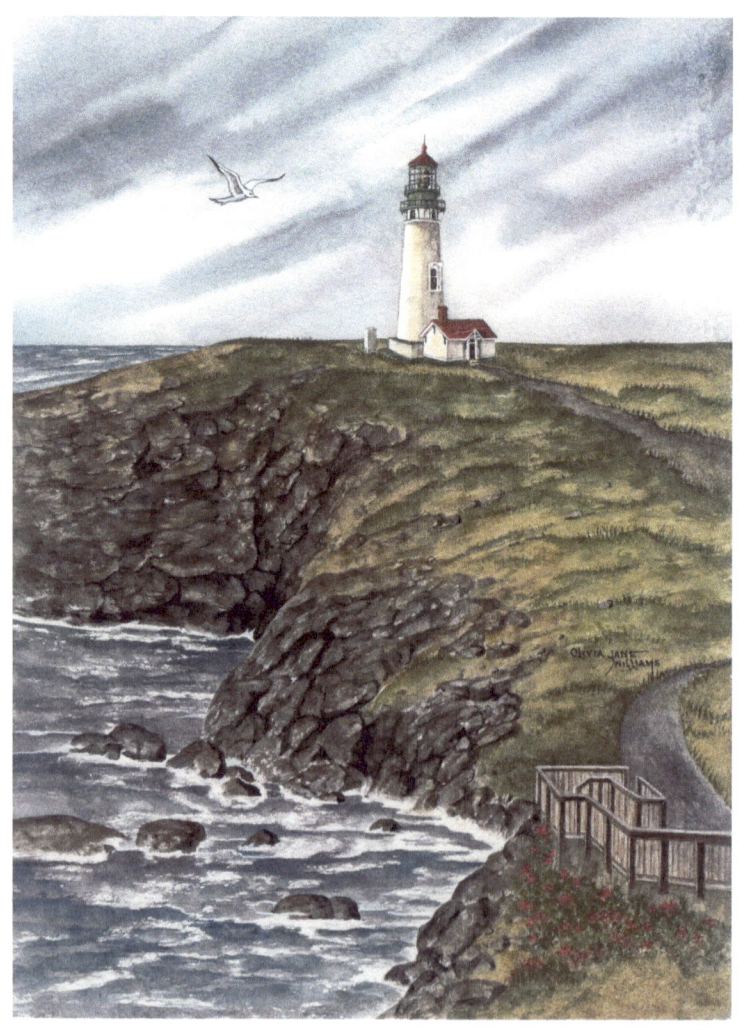

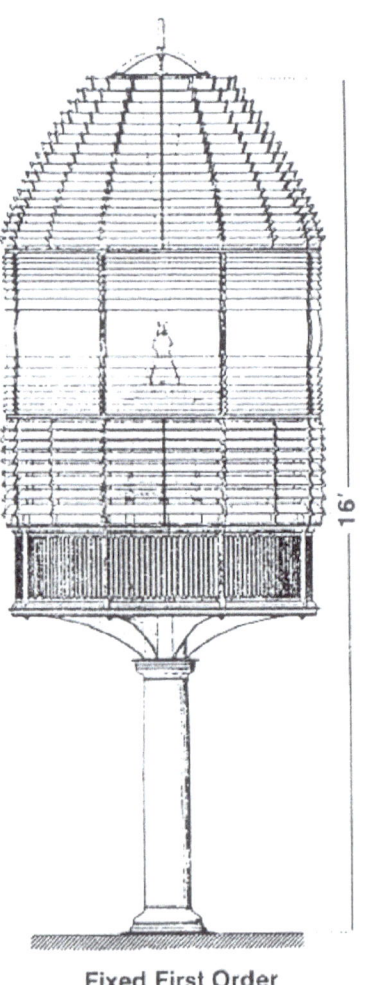

Fixed First Order

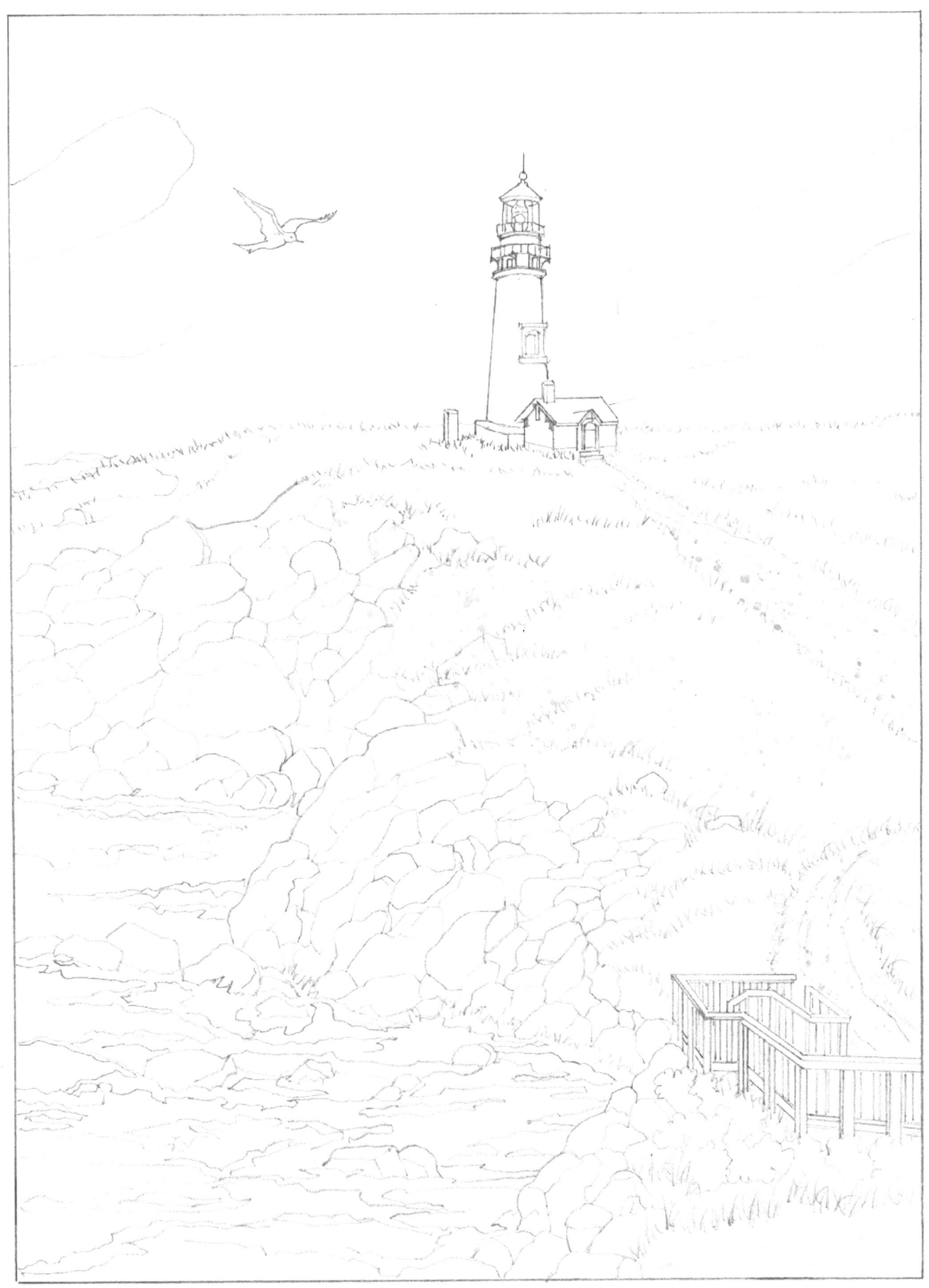

Yaquina Head - 47

Heceta Head Lighthouse, north of Florence, is considered one of the most picturesque on the west coast. It was completed in 1894. The sixty-five foot masonry structure overlooks the headland that marks it's name.

In 1775, Captain Don Bruno de Heceta, of the Spanish Royal Navy, led an expedition along the Pacific Northwest coast reaching as far north as the 59th parallel. Heceta waters are filled with craggy rock reaching far out into the ocean, dangerous to sea vessels. Equipped with a large first-order lens, and the height of its perch on the cliffs, the beam can be seen from twenty miles at sea.

Like several other lighthouses, Heceta Head has a resident ghost. Keepers, as well as guests, have reported some interesting encounters with the wraith.

Adjacent to the lighthouse is Devils Elbow State Park and a mile south, the famous Sea Lion Caves, home to the steller sea lion, and one of the largest natural sea caves on the Pacific coast.

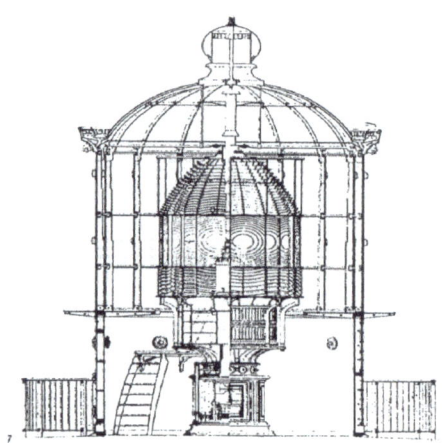

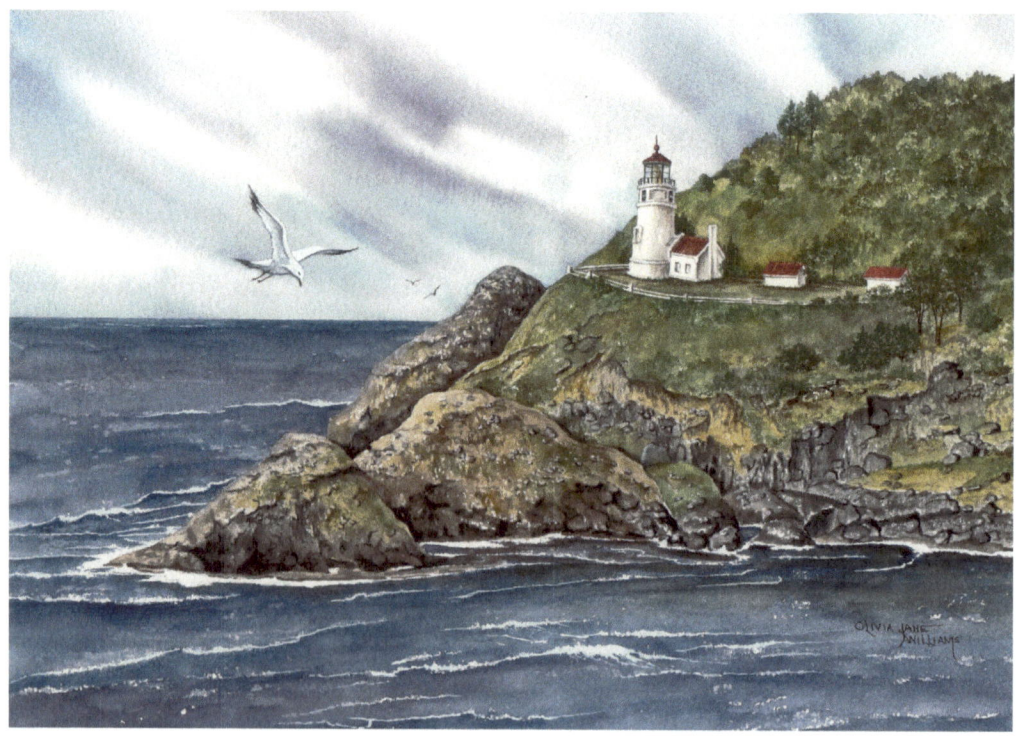

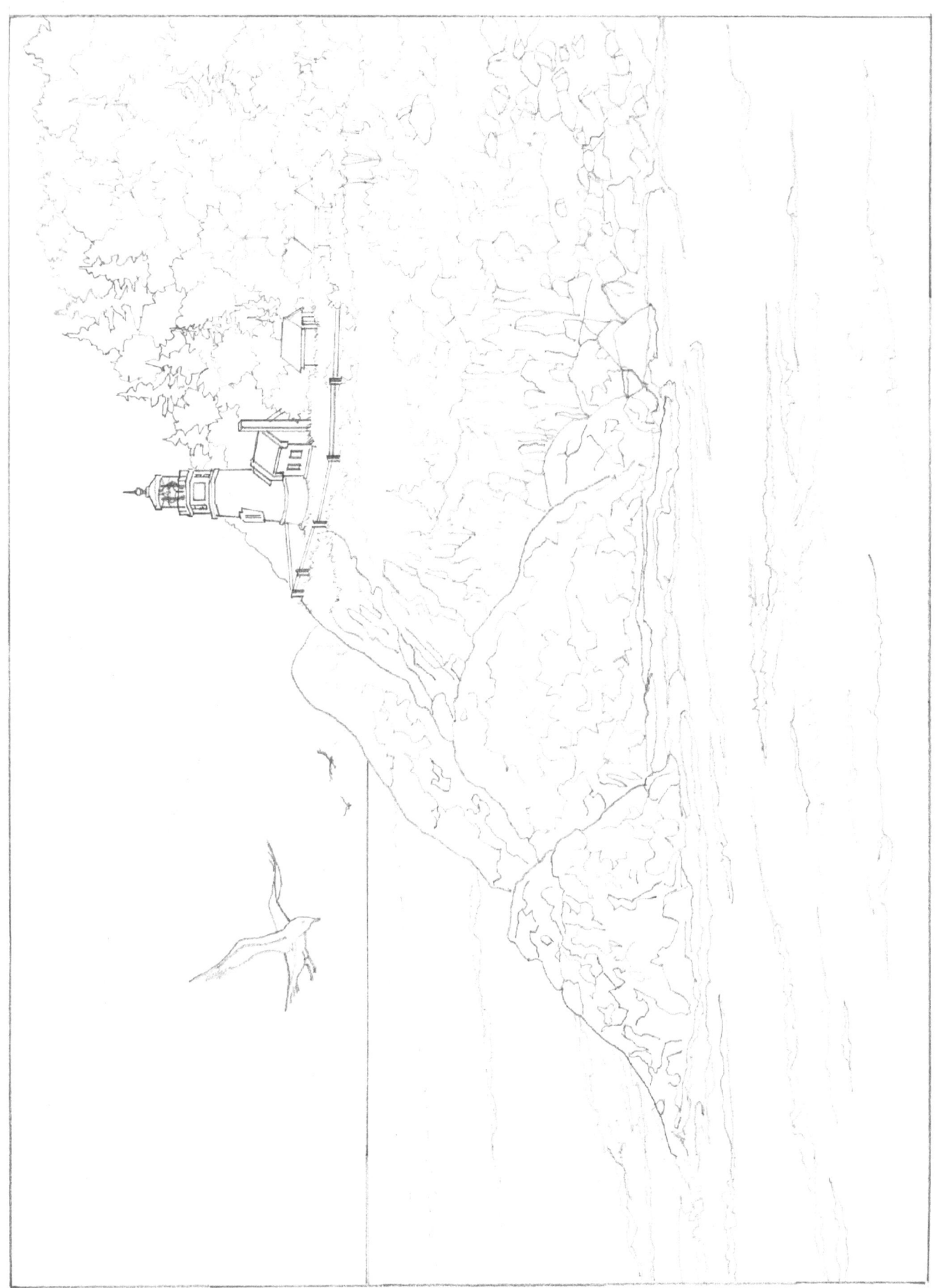

Heceta Head - 49

Umpqua River Lighthouse, erected in 1894, guards the river's treacherous bar. Located south of Reedsport, it replaced the original tower, built in 1857, which was claimed by the sea.

The elegant, sixty-five foot, white tower, surrounded by tall evergreens and sand dunes, was given a first-order Fresnel lens. Its beam is visible from nineteen miles off shore.

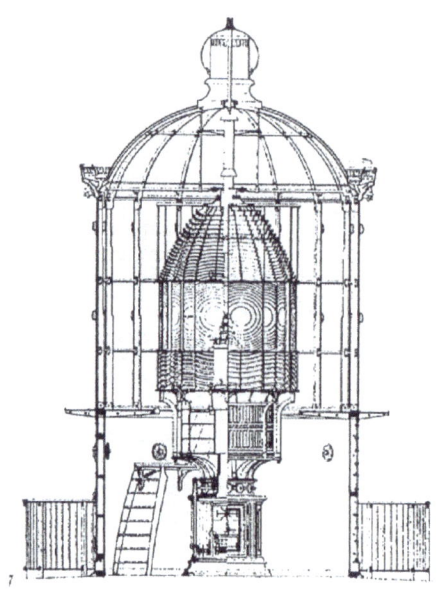

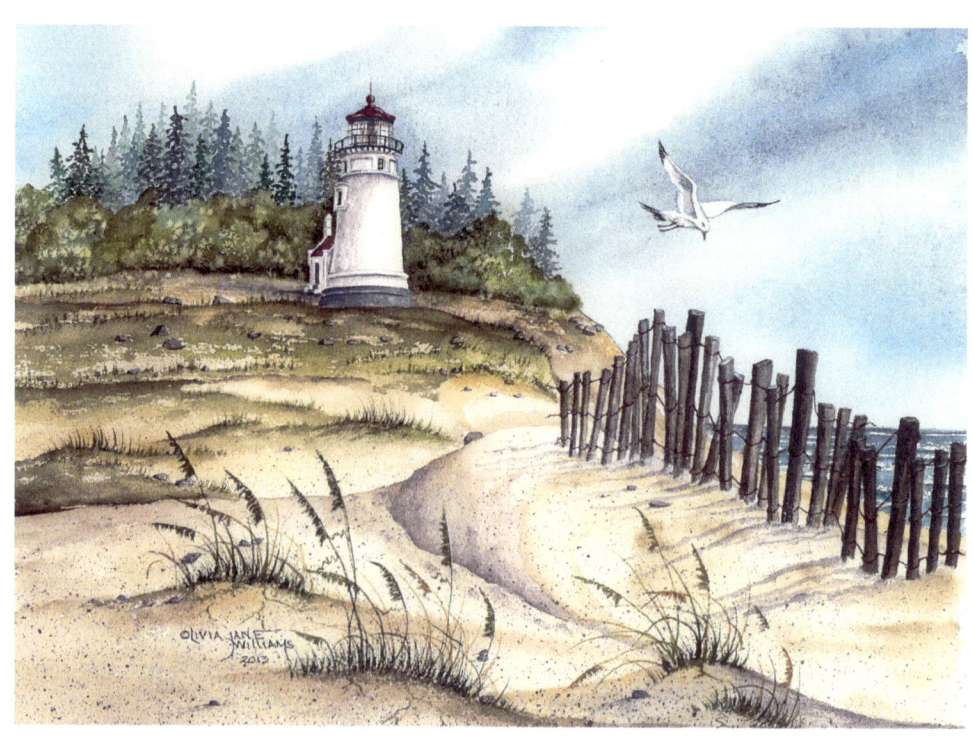

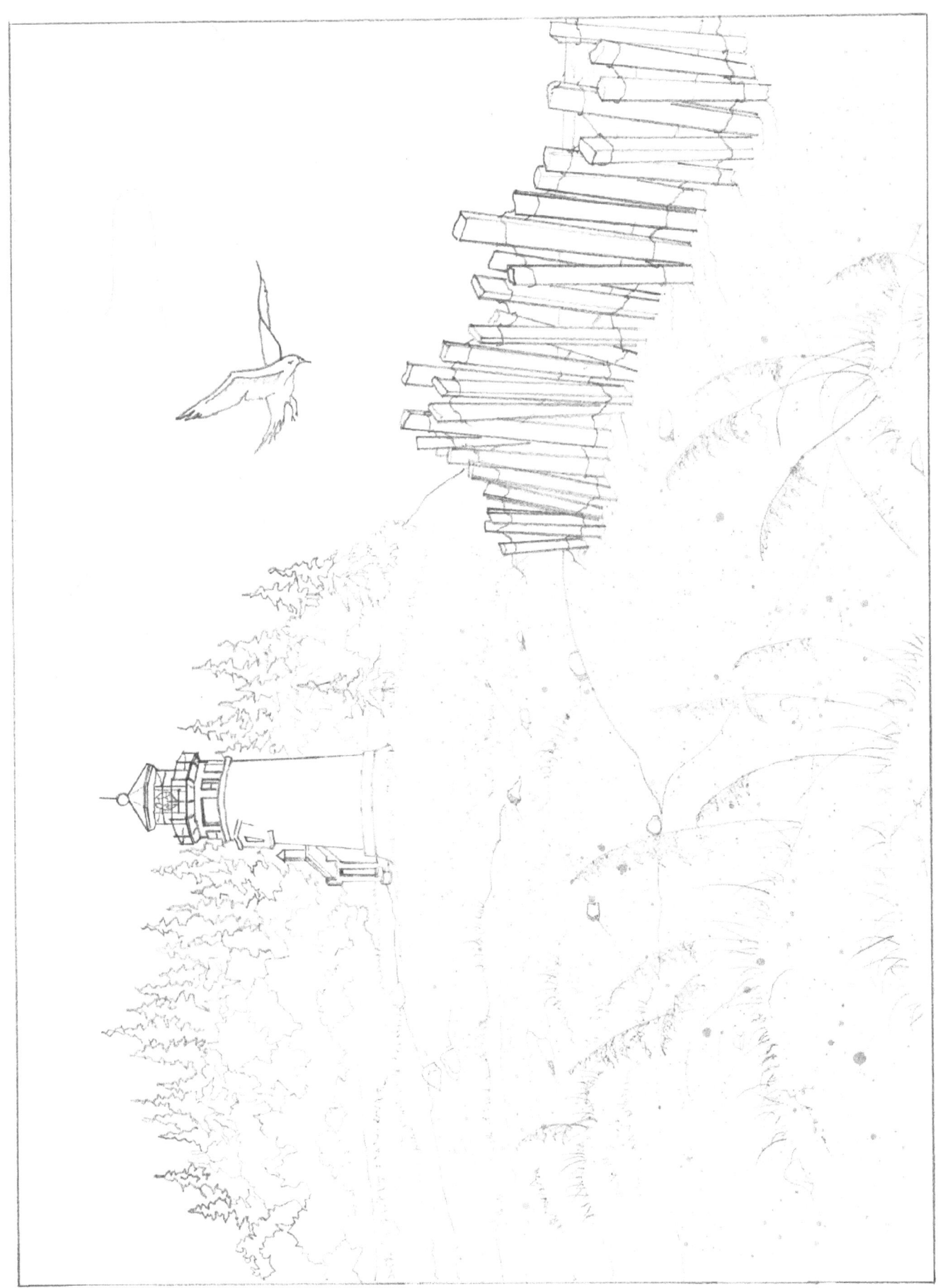

Cape Arago's first lighthouse was built in 1866, the second in 1908, and the present structure in 1934. Located south of Coos Bay, on an island which is connected to the mainland by an iron footbridge, the octagonal tower of reinforced concrete stands forty-four feet tall, is attached to a fog signal building, and has a fourth-order light which is visible from sixteen miles at sea.

Coos Bay bar is littered with the remains of countless shipwrecks. The channel shifts with tides and weather, and the island prone to erosion, is ever-changing. Jetties have been created on both the north and south sides of the bar allowing safer access to the bay. As a result, Coos Bay has become the soft-wood lumber export capital of the world.

Fourth Order Lens

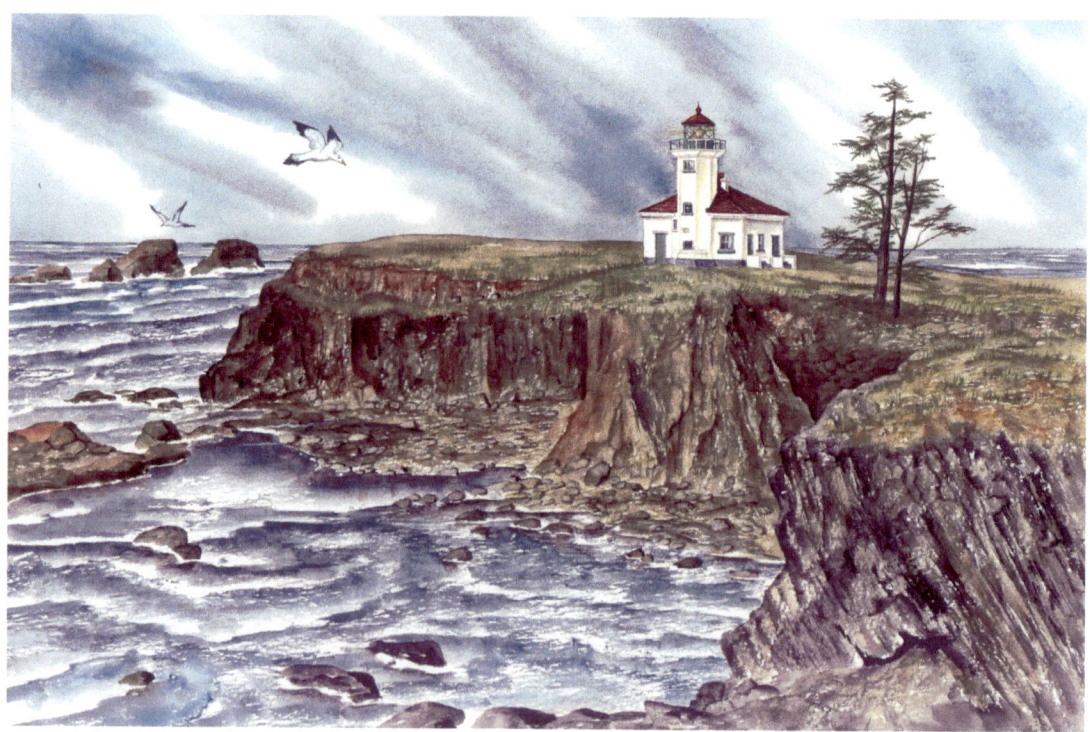

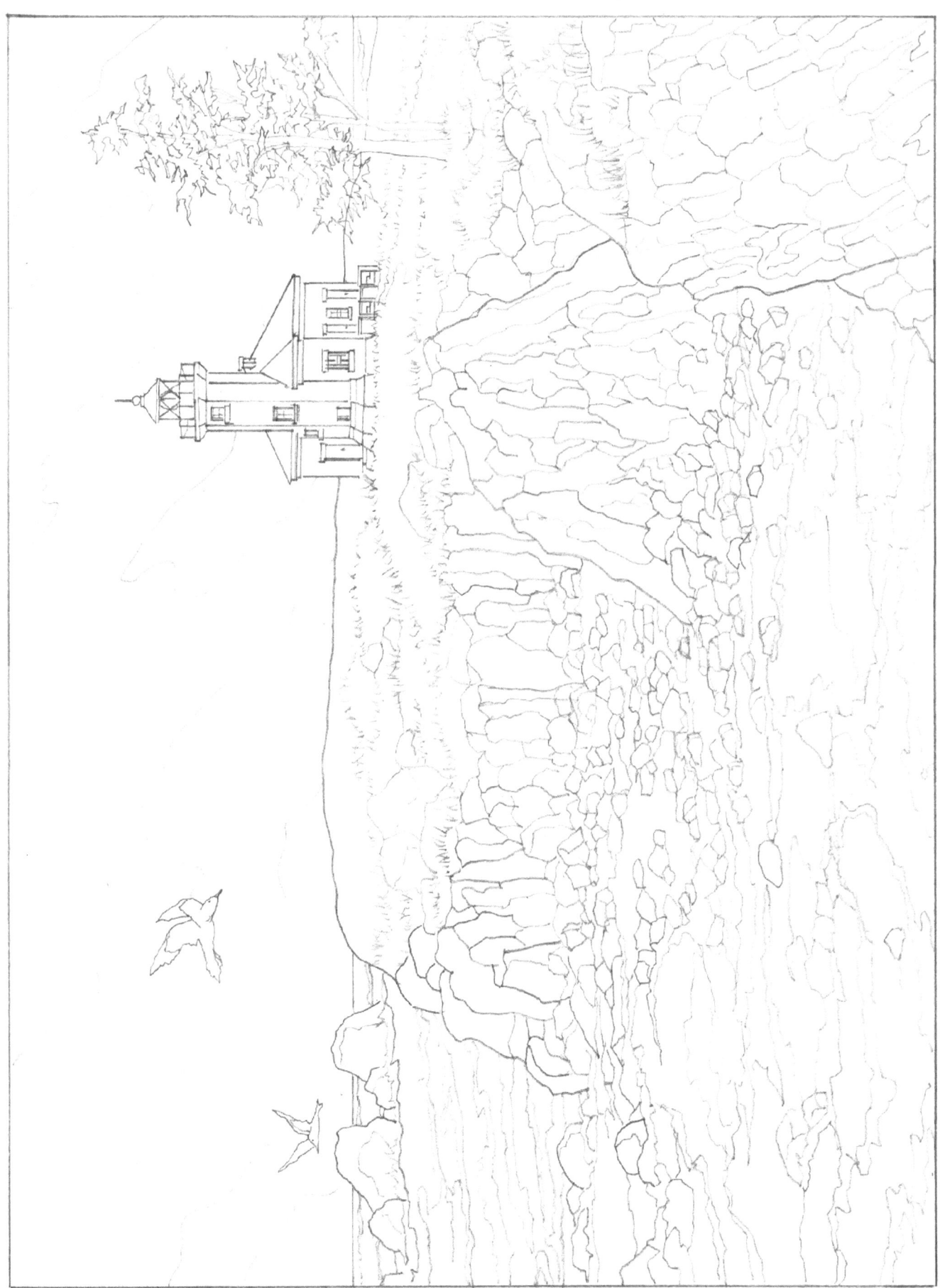

Cape Arago - 53

Coquille River Lighthouse, near Bandon, was constructed in 1896, at a cost of $17,600, and given a fourth-order Fresnel lens. Its unique forty-foot, octagonal tower sits next to Coquille bar, considered one of the most dangerous on the west coast. It serves as both a harbor entrance light and a seacoast beacon.

The Coast Guard abandoned the light in 1939, and it sat deteriorating for many years. After nearly 35 years of neglect and vandalism, the state of Oregon and Army Corps of Engineers agreed to share to cost of restoration. It is now an historic attraction of Bullards Beach State Park.

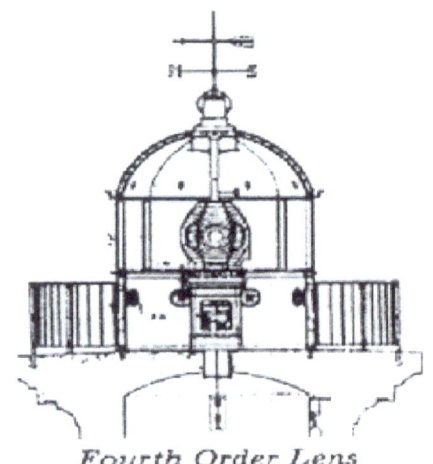

Fourth Order Lens

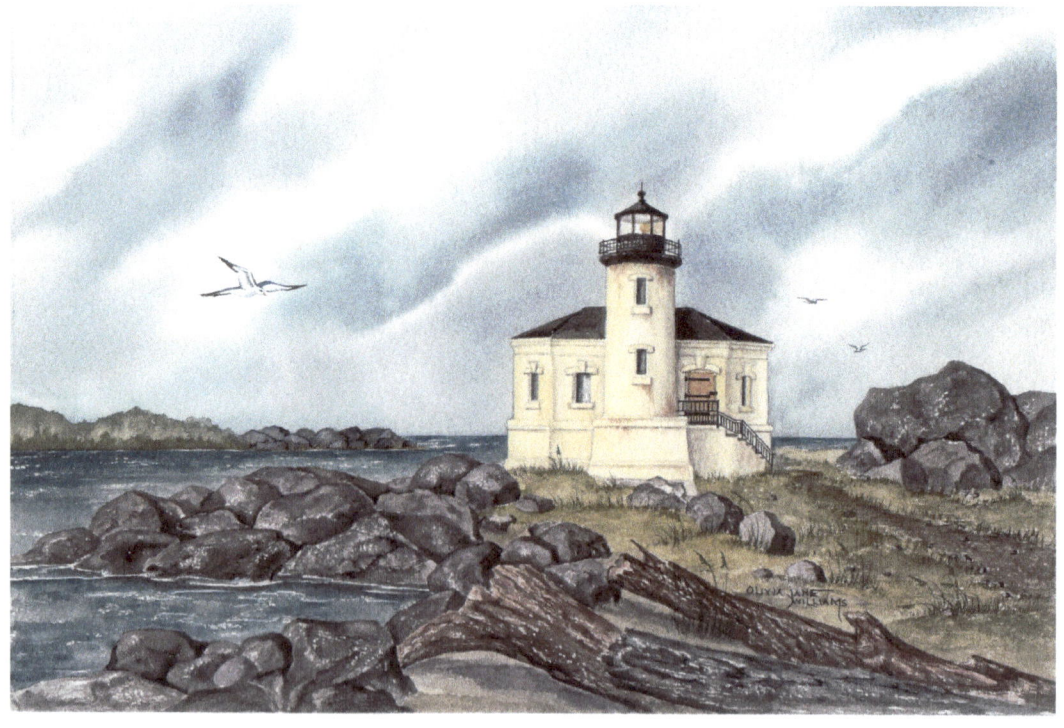

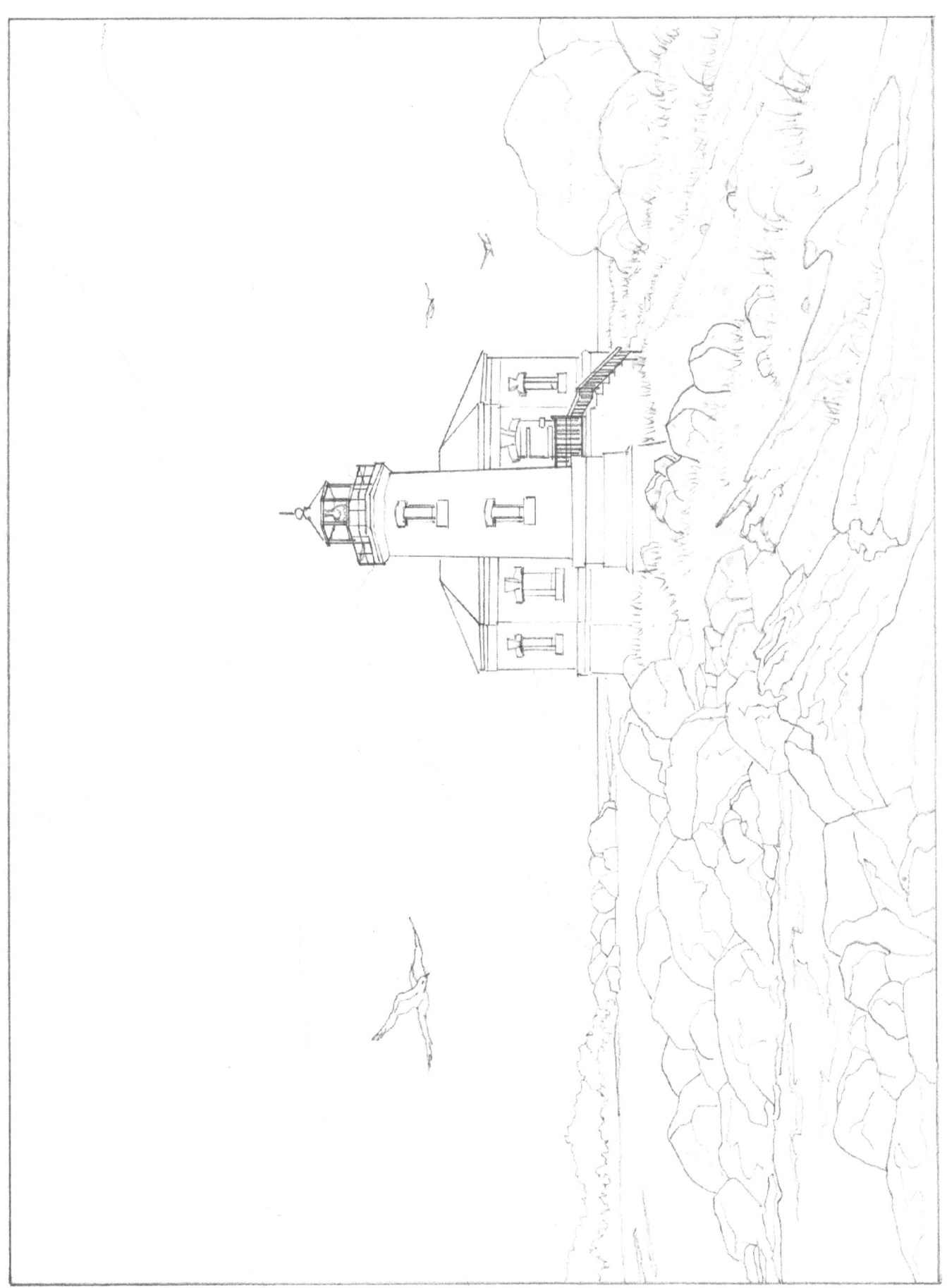

Coquille River - 55

Cape Blanco Lighthouse, completed in 1870, and located nine miles south of Port Orford, is Oregon's oldest active lighthouse. The fifty-nine foot conical-shaped tower was first lit December 20, 1870, with a first-order lens, but later replaced with a second-order Fresnel lens. Rising 245 Feet above sea level, the million-candle power light can be seen from twenty-two miles at sea.

The lighthouse at Cape Blanco, stands on Oregon's most southwestly cliff and guides mariners through some of the most dangerous waters in America. The remains of countless vessels are buried in the rocks along this stretch of the coast.

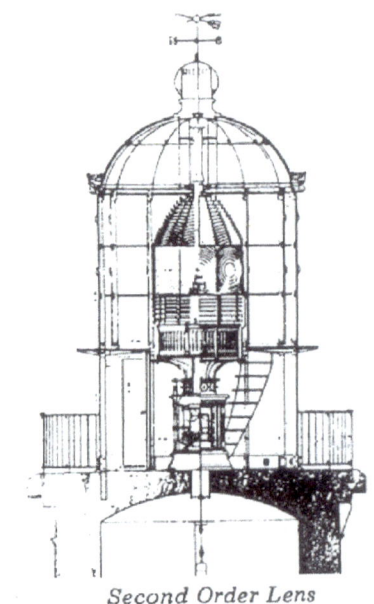

Second Order Lens

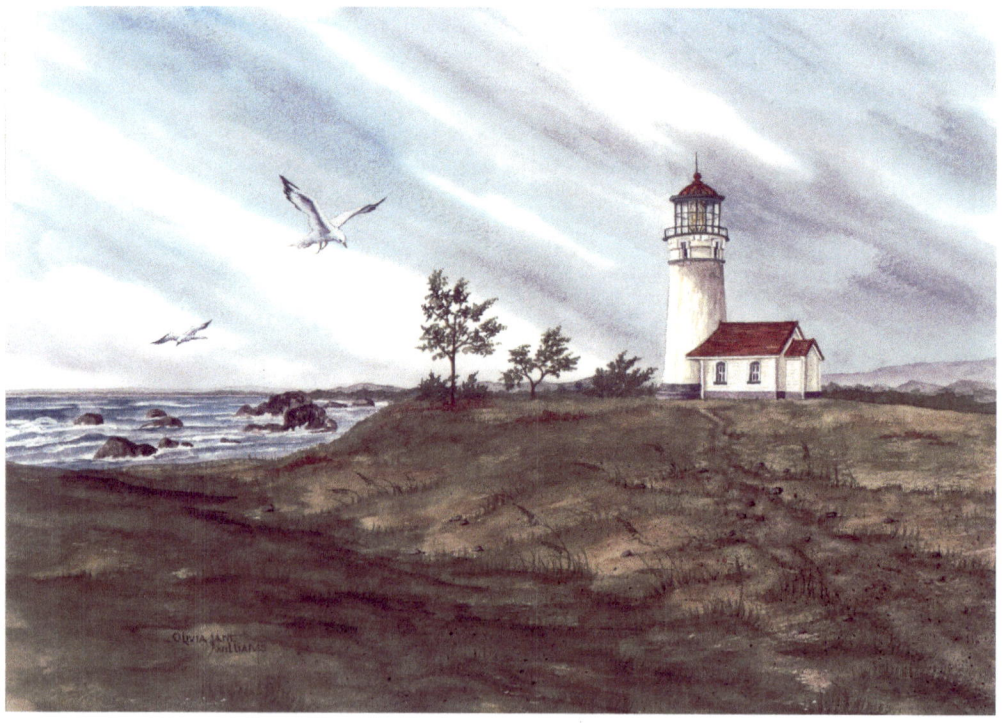

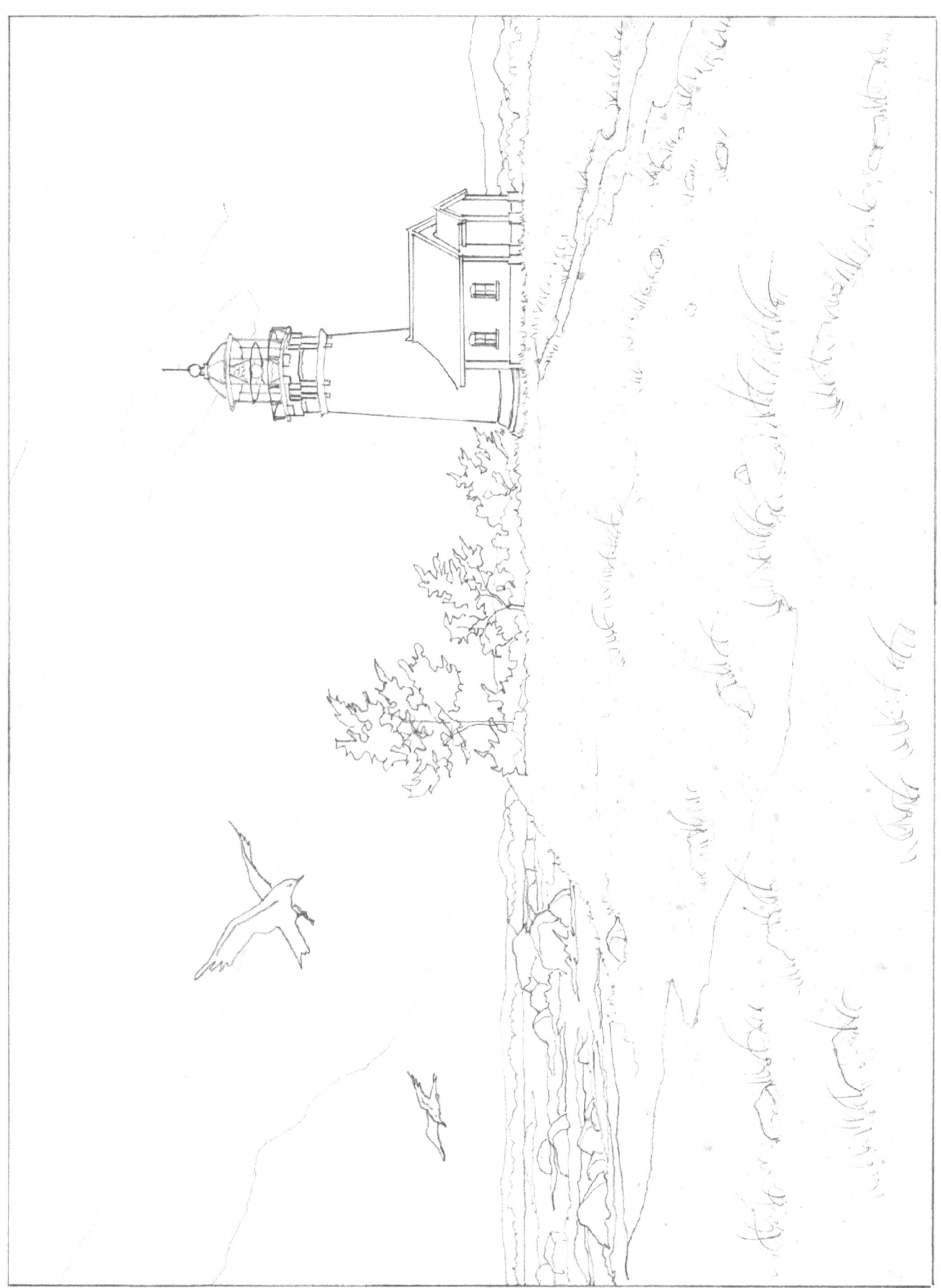

Cape Blanco - 57

Other treats for lighthouse lovers..............

the beautiful LIGHTHOUSE MAP contains all the images in this book and their locations............

Volume 1

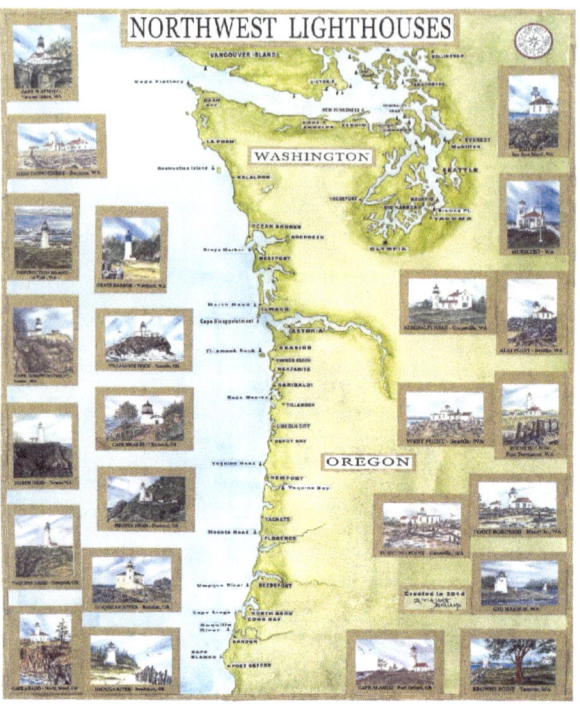

Map 8x10 $10 11x14 $20
plus postage

$10 plus postage

also available are all the lighthouses featured in this book matted in standard frame sizes and signed by the artist....................

anda special feature is the print remarqued in watercolor by the artist, which gives it a dimensional effect.

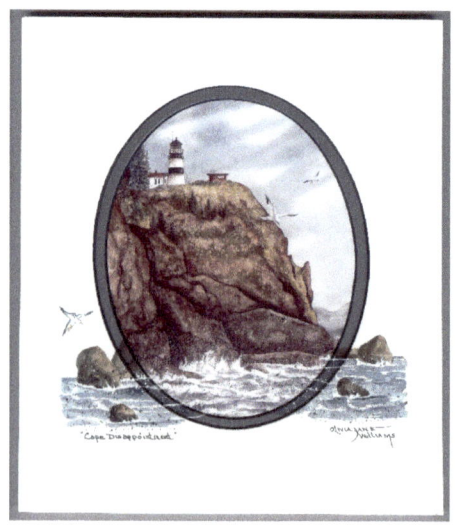

8x10 matted $15
11x14 " $25
plus shipping

remarqued print
8x10 $25 11x14 $40 plus post

.......purchase these and other images at my website: oliviajanewilliams.com

www.ingramcontent.com/pod-product-compliance
Lightning Source LLC
Chambersburg PA
CBHW051050180526
45172CB00002B/588